CREATIVE
PAINT
WORKSHOP

for Mixed-Media Artists

QUARRY

CREATIVE
PAINT
WORKSHOP
for Mixed-Media Artists

EXPERIMENTAL TECHNIQUES FOR COMPOSITION, LAYERING, TEXTURE, IMAGERY, AND ENCAUSTIC

BEVERLY MASSACHUSETTS

QUARRY BOOKS

Ann Baldwin

First published in the United States of America by
Quarry Books, a member of
Quayside Publishing Group
100 Cummings Center
Suite 406-L
Beverly, Massachusetts 01915-6101
Telephone: (978) 282-9590
Fax: (978) 283-2742
www.quarrybooks.com

Library of Congress Cataloging-in-Publication Data
Baldwin, Ann.
 Creative paint workshop for mixed-media artists : experimental techniques
for composition, layering, texture, imagery, and encaustic / Ann Baldwin.
 p. cm.
 Includes bibliographical references.
 ISBN-13: 978-1-59253-456-2
 ISBN-10: 1-59253-456-2
 1. Mixed media painting--Technique. I. Title.
 ND1505.B35 2009B4549
 751.4'9--dc22

 200803556
 CIP

ISBN: 978-1-59253-747-1
10 9 8 7 6 5 4 3 2 1

Cover and Interior Design: Claire MacMaster, barefoot art graphic design
Additional Design & Layout: Rachel Fitzgibbon, studio rkf
Photography: Ann Baldwin unless otherwise noted

Printed in Singapore

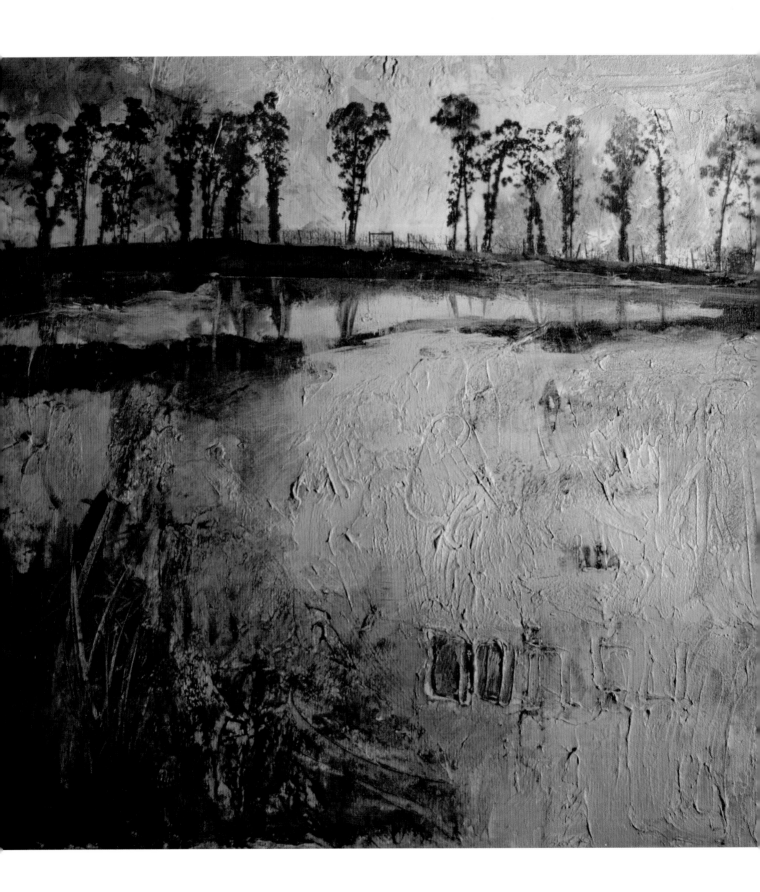

CONTENTS

Introduction

PAINT HAS MARVELOUS PROPERTIES. It can slide, it can drip, it can spatter, and it can crawl. It can pool and puddle, bloom and blossom, shine and sparkle, veil or reveal. As a substance, it is both sensuous and practical. I discovered paint relatively late in life and I have been in love with it ever since. I began as a watercolorist, enjoying its fluidity and transparency; became an oil painter, reveling in its richness; and eventually discovered the versatility and forgiving nature of acrylics. Being self-taught, I was astounded at what I could get away with in acrylic painting. Make a "mistake"? Cover it up! Light colors over dark? No problem. Transparent or opaque? The choice is yours. Like to paint fast? It dries quickly.

Mixing media has become very popular lately, but it's really nothing new. Degas, Picasso, Kurt Schwitters, Robert Rauschenberg, Jasper Johns, Joseph Cornell have all mixed their media creatively. When we were children, didn't we grab just about anything that would make a mark on paper in order to express ourselves? Self-expression is what creativity is all about, but as adults we tend to worry about sticking to the "rules." While my own attitude is that rules are made to be broken, I am aware that to do so requires a certain amount of confidence. In chapter 2, I demonstrate several different approaches to composition, giving you a wide choice and, in the end, encouraging you to be yourself. In chapter 3, I take a look at the elements of design more as a way of sparking ideas than of blinding you with science.

In this book I will demonstrate how to use paint, crayons, colored pencils, oil pastels, pens, acrylic mediums, found images, photographs, fabric, and wax to create vibrant and colorful works of art. Sometimes I will mix five or six media for a multilayered look. At other times I may use only two or three. Usually it's a pretty messy business, so put on your old clothes, clear a space on the countertop, and let's get started!

RIGHT: *Addition*,
Ann Baldwin, 15" x 11"
(38.1 x 27.9 cm), collage,
ink, acrylic, oil pastel.

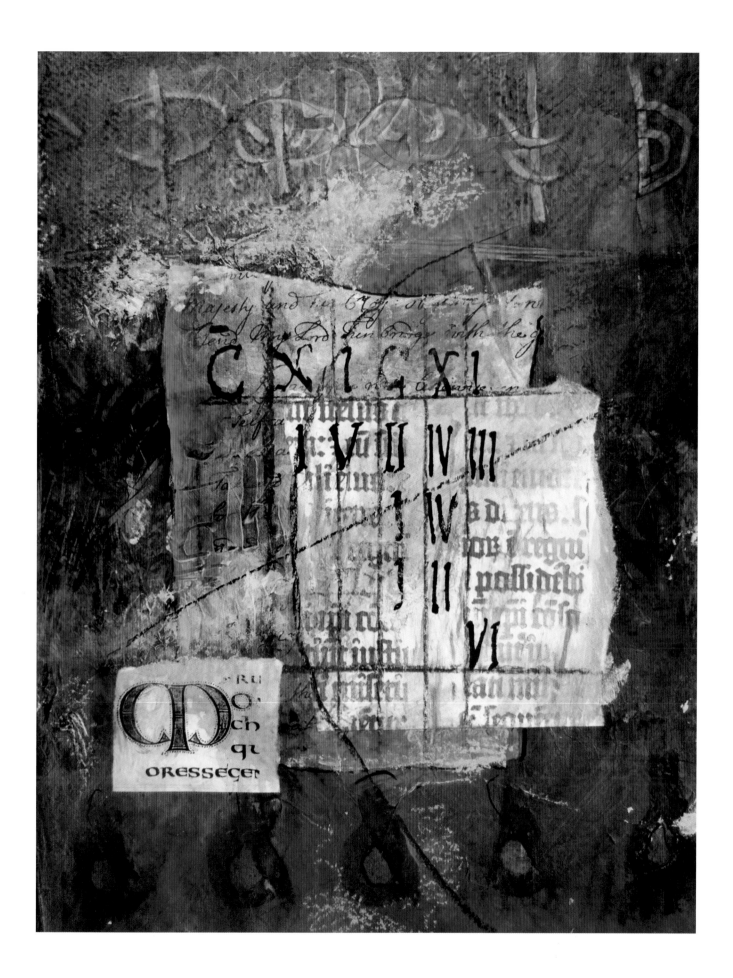

Getting Started

Where mixed media is concerned, almost anything goes. Here, however, the focus is on two-dimensional mixed-media painting. The recommendations that follow reflect personal preferences as well as the essentials.

Because the array of media is so large, you may be tempted to cram too many types into any one painting. Certainly try everything eventually—but not all at once! Your techniques will develop best if you concentrate on just a few materials: a series of paintings using only tissue paper for texture; another exploring acrylic with ink.

Supports

A support is anything on which you create your work of art. Your choice may depend on textural preference, cost, or convenience. The advantage of canvas and board is that they can be displayed without framing. Paper uses less storage space, but must ultimately be displayed under glass, adding to the cost.

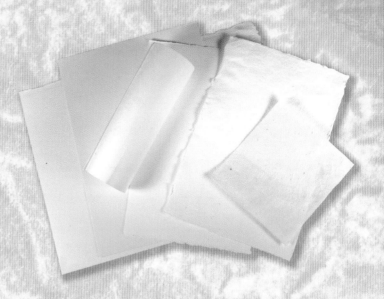

Watercolor paper in various weights and surfaces, and rice papers

PAPER

For smaller pieces, paper is the most versatile and can be very economical. Archival watercolor paper comes in various weights and surfaces. 140 lb. (64 kg) cold press is good choice to work with, as it is strong enough to take both heavy textures and some punishment—sanding, for instance. It has enough "tooth" (texture) to make for interesting dry-brush effects and random mottling when thin glazes of paint are applied. Another advantage of paper of this weight is that it can easily be torn for cropping to a smaller size. If you tear it roughly, you can simulate the appearance of a deckle edge. It is also relatively easy to affix to a backing mat before framing. This weight of paper will sometimes buckle, depending on how much liquid soaks into the fibers during gluing and painting. A simple remedy is to place your dry painting facedown on a hard surface, then spray the back of the paper with water. Place a towel over it to absorb the moisture, and then a heavy object on top to keep it flat. Leave it overnight. The next day your painting should be perfectly flat and ready to mat.

A 300 lb. (136 kg) paper is very thick, durable, and will not buckle, but it is harder to mat, needing very strong hinges. Usually 90 lb. (41 kg) paper is too lightweight for textured work.

Some handmade papers from India are 200 lb. (91 kg) and very tough. They often come in nonstandard sizes and are described as "natural white," meaning they have not been bleached and have a warm tone. Some common names for Indian papers are Nujabi, Punjabi, and Indian Village.

LEFT: *Having a dedicated, well-lighted space to make art is a luxury. I started in a small back bedroom; took over the end of the garage; took over the entire garage; and eventually, moved to a house with a large, airy room above the garage.*

Hot press paper is slick and makes a nice smooth surface for initial drawing or writing.

You can also paint on handmade Asian papers such as washi and yuzen. Masa, which is machine made, is inexpensive, and very versatile. Many of these papers have no sizing, allowing the paint to soak through to the back. In this case, a couple of preliminary coats of matte medium will provide the necessary base coat.

CANVAS

Painting on canvas has the advantage that the work doesn't have to be matted. If the canvas has deep sides (1.5" to 3" [3.8 to 7.6 cm]), these can also be painted, making framing unnecessary. If you intend to make larger artwork, canvas is probably your best choice. When purchasing a canvas, check that it is not warped. You can do this by placing the longest side against the end of a shelf in the store. Assuming the shelf is perpendicular to the floor, the corner of your canvas should fit snugly into the space. Then hold your canvas with the front flat against the broad end of a shelf. If it won't lie flat, it's warped. These quick tests can save you from wasting money. Be aware that a canvas on narrow stretcher bars will easily warp over time. Canvas board, which is canvas mounted directly to cardboard, is even more vulnerable to changes in atmosphere.

When collaging onto canvas, you will need to use glue on both surfaces: the back of the material you are gluing down and the surface of the canvas itself.

To adhere heavier papers, hold a piece of heavy card or thin wood against the back of the canvas, while pressing the collage onto the front surface. Canvas has considerable "bounce" and it's easy for air bubbles to get trapped between your collage and the support.

The weave of the canvas accepts paint very differently from paper. I prefer pre-gessoed canvas, which has such a bright white color that transparent glazes of paint achieve a wonderful glow.

Summer's End, Ann Baldwin, 12" x 12" (30.5 x 30.5 cm), fluid acrylic, digital photographs, ink on pre-gessoed canvas.

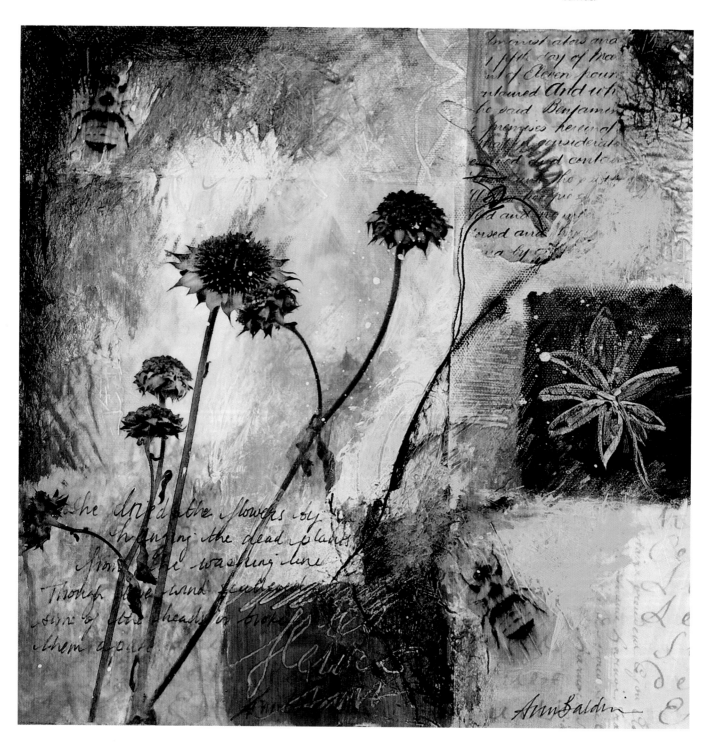

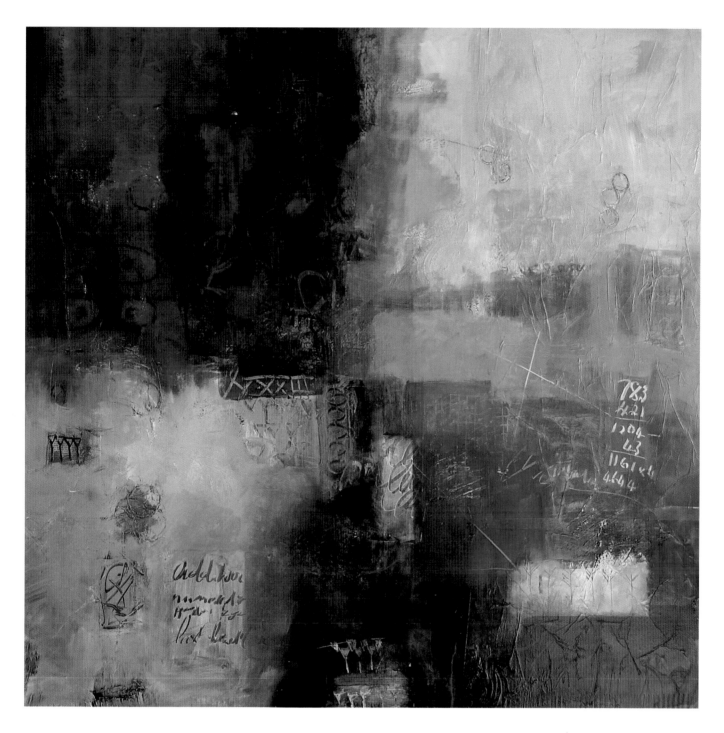

Counting Systems #3,
Ann Baldwin, 48" x 48"
(121.9 x 121.9 cm), acrylic,
tissue paper, ink on pre-
gessoed canvas. Private
collection.

BOARD

Masonite is cheap and can be bought in hardware stores, or in art stores, where typically it can be cut to specified sizes for you. It can be covered with several layers of gesso in preparation for painting, or you can begin with a layer of collaged paper. Since it warps easily, it's a good idea to frame it sooner rather than later to brace it. You can also glue stretcher bars or pieces of wood to the back to form a "cradle." Companies such as Ampersand sell pre-cradled wooden panels. Birch plywood is another possibility.

Between Seasons,
Ann Baldwin, 12" x 12" (30.5 x 30.5 cm), fluid acrylic, ink on birch panel.

The tree at bottom right has been scraped into the paint using a rubber shaper. The hard wood surface is ideal for this technique.

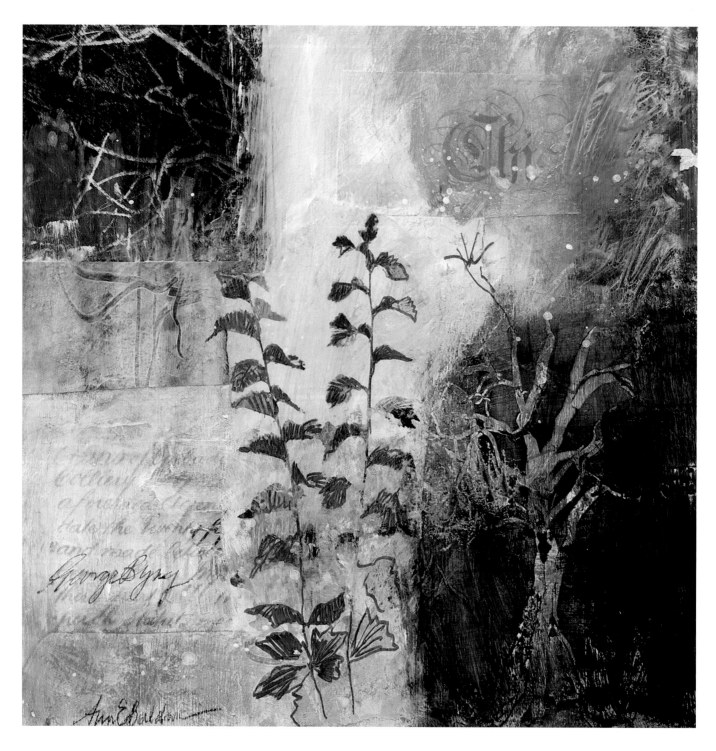

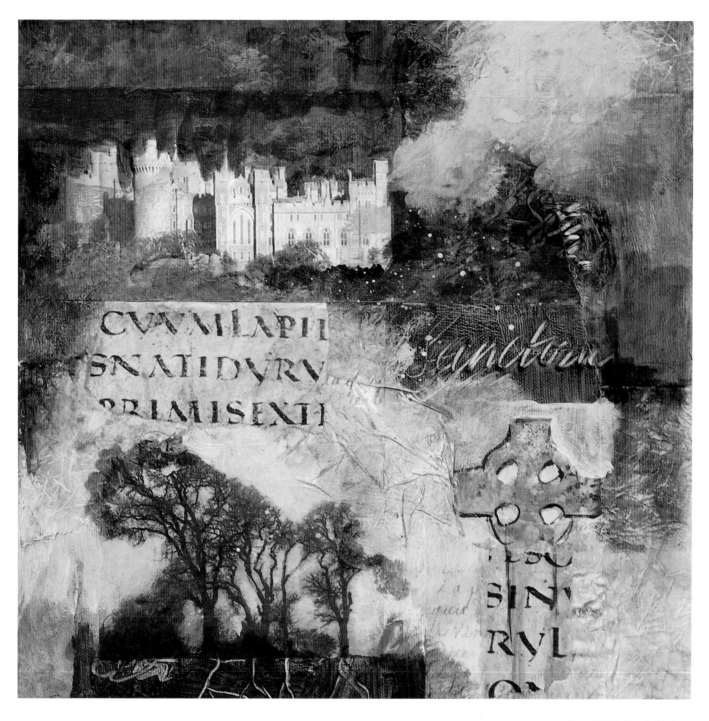

Arundel #2, Ann Baldwin,
12" x 12" (30.5 x 30.5 cm),
mixed media on Masonite
panel. Private collection.

Painting Media

This book focuses primarily on acrylics because they are very versatile. The polymer resin used as a binder in the paints is adhesive, which can be useful when applying collage. Acrylics can be mixed with water or acrylic medium, so no unhealthy solvents are involved. By varying the amount of water or medium added, a huge range of tones can be created from very light to very dark. They dry fast and they are waterproof when dry, which makes them an ideal choice for working in layers.

For glazing—painting on a thin, transparent layer—fluid acrylics are your best choice. Even opaque pigments, such as cadmiums, titaniums, ochers, and ceruleans, can be made transparent with the addition of matte or gloss medium. How do you know which paints are the most transparent? Golden provides a small strip of paint on the outside of each bottle or jar to help you judge. If the following words form part of a color's name, you can be sure they are by nature transparent: dioxazine, phthalo, or quinacridone. Other transparent paints are Transparent Yellow Iron Oxide, Transparent Red Iron Oxide, and Jenkins Green.

Jar or tube paints are heavier-bodied with greater coverage, though the colors mentioned above will still be transparent unless piled on thickly. When applied with bristle brushes or palette knives, they are useful for creating texture.

Watercolor paints can be used as the background layer of a mixed-media piece, but they don't work well over acrylics. The paint tends to "bead" over acrylic, which has a slippery surface, unless it is mixed with plenty of water and allowed to soak into the support.

Oil paints can be used over acrylics, but acrylics can't be used over oil. Since acrylic adhesives can't be mixed with oil paints, it is also harder to find ways to attach collage to an oil painting.

Encaustic paints, covered in chapter 7, allow collage elements to be encased in wax.

HOW SAFE ARE YOUR PAINTS?

Acrylic paints consist of a polymer resin binder mixed with pigment. The resin is adhesive, which is convenient when you are adhering other media. There is a mistaken belief among some artists that acrylic paint is entirely nontoxic. The binder is fairly harmless, but the minerals used in the pigments—cadmiums, cobalts, manganese particularly—are hazardous whether in oils, watercolors, or pastels. If you have open cuts on your hands, toxic substances can enter your bloodstream. For this reason you should always wear protective gloves—latex or nitrile. Yes, they take a bit of getting used to, but if you wear them regularly, you'll soon cease to notice them. Just make sure they're a good fit.

Breathing dust particles from dry pastels is also hazardous, so wear a mask. Should you decide to mix your own paints from powdered pigments, you'll need to have your hands in a special sealed chamber while you do it.

Many famous artists of the past (van Gogh and Goya, to name but two) are thought to have suffered serious health problems due to contact with hazardous materials in paint. Never eat your paints! That includes putting your fingers in your mouth while painting, which might happen if you bite your nails or stop for a snack without washing your hands. You want to live long enough to create more art, right?

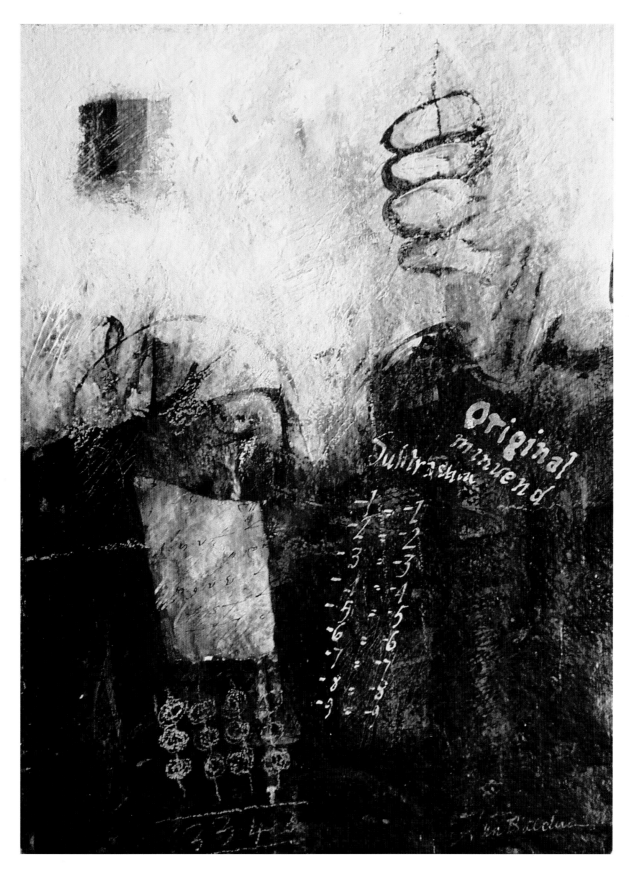

Minuend, Ann Baldwin,
15" x 11" (38.1 x 27.9 cm),
heavy-bodied acrylics, white
ink, collage on 140 lb.
(64 kg) rough watercolor
paper. Private collection.

Drawing Media

Pens, pencils, pastels, and oil crayons are all useful in mixed-media painting. Bear in mind that acrylic is a wet medium, so your drawing media will need to be waterproof unless applied as a final touch. Even then, they won't work if you plan to add a coat of protective medium or varnish to the piece.

There are many so-called waterproof pens on the market, but test them first on a separate sheet of paper. Brush a little water over the ink, after you have allowed it to dry. You'll soon see if it "bleeds." I have found Sharpie pens to be the most reliable and they come in a variety of tip sizes. For a more creative approach, try using acrylic ink (FW inks come in many different colors) with a calligraphic nib pen.

Graphite pencils are not entirely waterproof, but if a layer of soft gel medium is brushed over gently, the marks will be prevented from dissolving into a gray mess when the next layer is applied.

Cheap oil pastels contain very little oil and plenty of filler, making them very suitable for layered work. Unlike true oil sticks, they will not entirely resist acrylics, so they can be

Waterproof pens come with a variety of tips

Oil pastels, wax-oil crayons, and colored pencils

easily covered up. They also write well on even the most plastic acrylic paint. The dry particles in charcoal and soft pastels make them vulnerable to lifting by wet media, so it's best to avoid using them.

The ingredients of crayons and colored pencils vary widely. Those with hard leads will not deposit color on a polymer medium or paint surface. The softer and creamier the pencil, the more likely they are to work. Of course, you can always use colored pencils to decorate your pieces of paper collage before they are stuck down. Black-and-white images colored in with colored pencils can be fun. Be absolutely sure that you are not using water-soluble crayons or pencils—usually labeled "watercolor"—or the marks will turn to wet paint when subsequent layers of paint are added. Caran d'Ache makes stick wax-oil crayons called Neocolor I, which work extremely well on top of acrylics, even when there is texture underneath. Though more expensive than most drawing crayons, they are waterproof, lightfast, and come in a variety of colors.

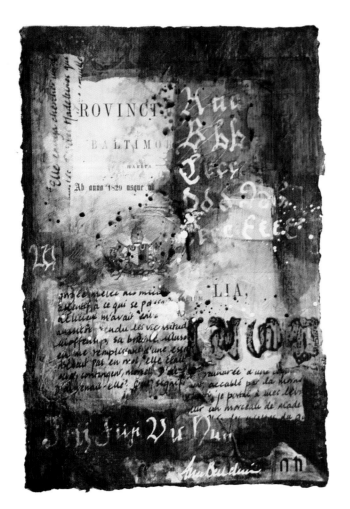

Provincalia, Ann Baldwin,
11" x 6" (27.9 x 15.2 cm),
fluid acrylic, waterproof
white and black ink, collage
on 140 lb. (64 kg) cold press
watercolor paper. Private
collection.

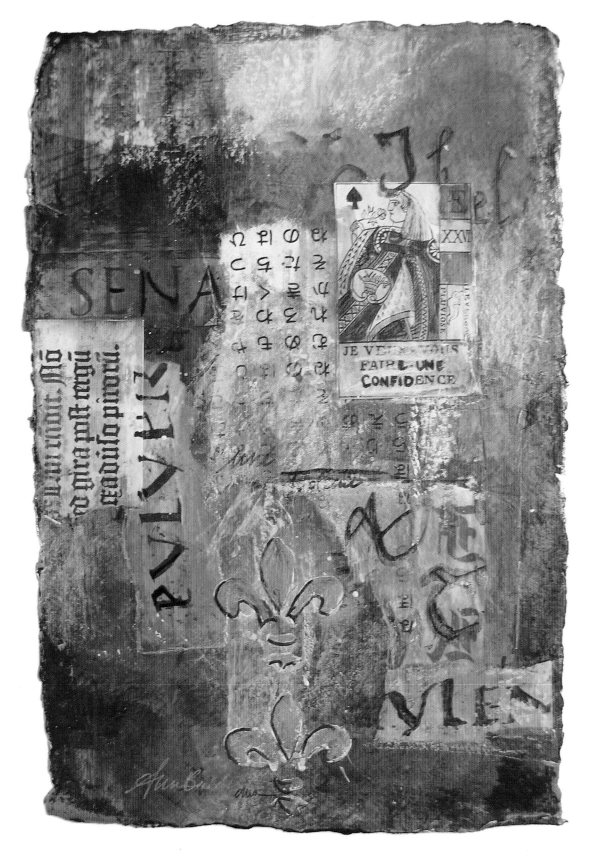

The Queen's Secret,
Ann Baldwin, 11" x 5"
(27.9 x 12.7 cm), acrylic,
ink, Caran d'Ache wax-oil
crayons on 200 lb. (91 kg)
Indian handmade paper.
Private collection.

Mediums and Glues

There is an exciting array of acrylic mediums available today. They vary in viscosity from the very fluid (regular matte or gloss medium), to a substance so thick that it can only be applied with a palette knife or spoon (extra-heavy gel). Some are smooth and slippery, like the gels; others are textured with sand, lava, beads, and fibers. Although all appear white or gray in the jar, some dry hard and opaque, like the modeling pastes; others dry clear. When allowed to dry thoroughly—which can take a while—the pastes can be sanded or even carved.

Golden Light Molding Paste is as light as meringue and, because it is full of tiny air bubbles, it dries much faster than other modeling pastes. This makes it the ideal choice for use in raised stenciling (see chapter 6).

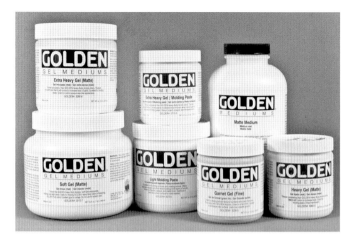

Acrylic mediums come in a variety of textures and thicknesses.

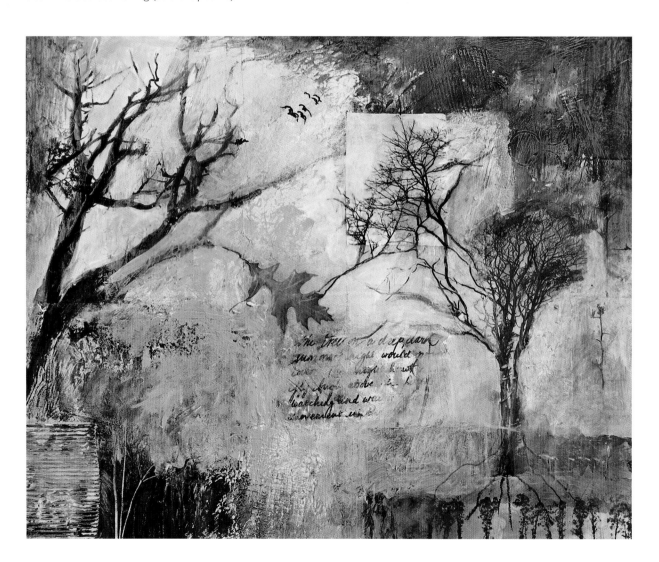

Flying High, Ann Baldwin, 18" x 24" (45.7 x 61 cm), acrylic, ink, crayon, digital photographs, light modeling paste on canvas. Private collection.

All acrylic mediums are adhesive and can be used to glue collage. The heavier the collage item, the thicker the medium should be. Regular matte medium is ideal for all but the thickest papers and fabrics, whereas heavy card and small objects will need to be stuck down with heavy gel or extra-heavy gel. A paste called YES! is ideal, too, for gluing thicker papers and card that you want to ensure will lie flat. Be aware that the wetter the medium, the more likely it is to affect the fibers in your thinner collage papers, causing them to wrinkle and crease. You may like this effect or you may prefer to avoid it.

All acrylic mediums can be mixed with acrylic paints to change their consistency or to extend them.

Regular fluid matte medium can be used to glue down all but the thickest papers.

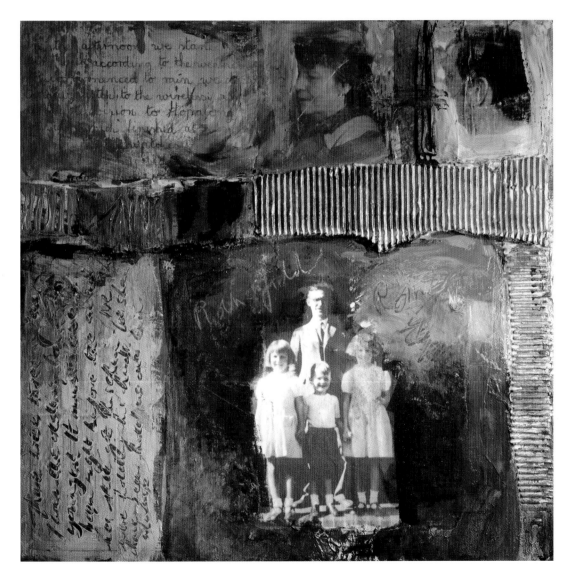

The Way We Were, Ann Baldwin, 12" x 12" (30.5 x 30.5 cm), acrylic, collage on canvas.

Corrugated cardboard was glued down with heavy gel matte medium.

Chapter 2

How to Compose

How can you create an arrangement of paint, collage, and drawing that looks good? Alternately, how do you avoid your mixed-media collage from looking as if you just stuck on a load of junk?

Composition is a tricky issue. Opinions about balance, flow, rhythm, focal points, mood, and meaning vary considerably from one person to the next. What appears in balance to one person may seem out of whack to another. Unless the meaning of a piece is spelled out very obviously, there can be as many meanings as there are viewers. There are "rules," but an artist is free to ignore them. Just be prepared for the criticism if you adopt a more risk-taking approach.

Bisections #3,
Ann Baldwin, 30" x 40" (76 x 102 cm), acrylic, collage, modeling paste on canvas.

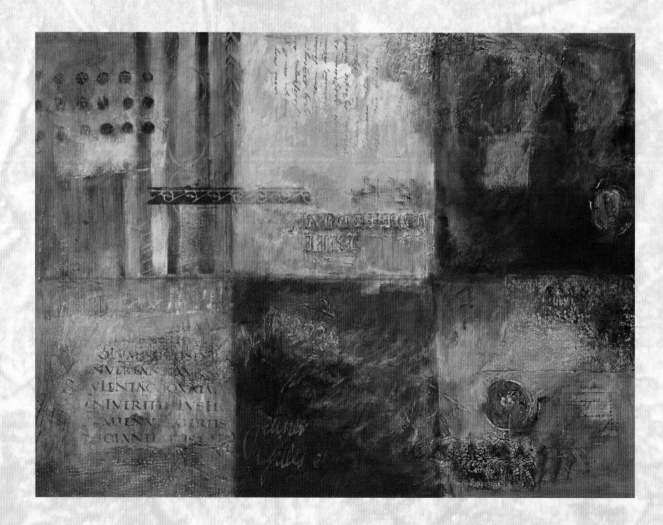

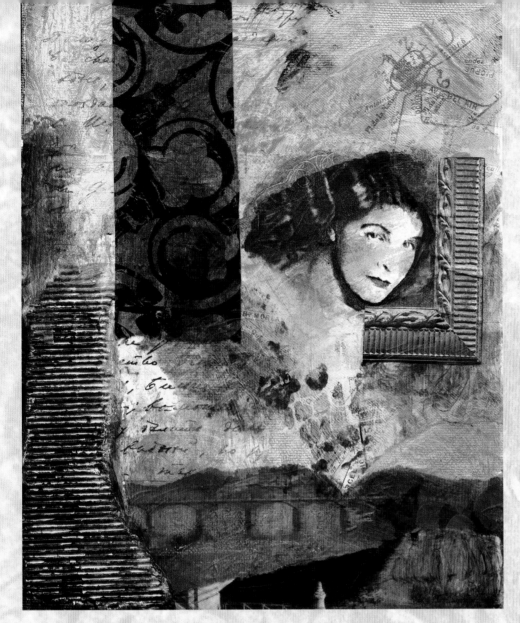

Avenue de Bel Air,
Ann Baldwin, 12" x 9"
(30.5 x 22.9 cm), collage,
acrylic on canvas.
Private collection.

*This small piece is given
depth by the inclusion of text
and maps in the background.
The focal point is further
emphasized by the picture
frame. The only textured
element is the corrugated
cardboard. A vertical strip
of strongly patterned tissue
paper has been added to
balance it.*

Professional photographers know just what to include in the frame
and what to leave out. They look through the viewfinder and move
the camera until everything they want is in view.

As a mixed-media artist you have more freedom than a photographer.
You can start with the subject matter or just paint in a background
color. If, later on in the process, you decide that you don't like some
of the content, you can simply paint or collage over it. If you realize
that your intended focal point isn't "popping," you can change its
color, its value, or its texture to make it more obvious. If you were
aiming for balance and your painting appears weighted too heavily
on one side, you can add a shape on the other side to even it out.
If your picture ends up looking "blah," there are dozens of ways to
liven it up with more saturated colors, heavier textures, lively super-
imposed lines, more detail. Of course, you probably won't want to
do all those things. Even one could make all the difference.

FOLLOWING AND BREAKING RULES

Traditional art teachers often instill in their students certain tried and tested rules:

- Never put your subject in the middle.

- Every picture needs a focal point, preferably one-third of the way in from the side and one-third of the way up or down the page.

- Keep the darkest areas at the bottom.

- Avoid placing objects at the extreme edges.

The rules provide a safe approach to composition but not always an exciting one. If you go into an art gallery, the paintings you are most likely to notice are the ones that are the least predictable. Of course, you might not like them, but that is subjective. How often have you disagreed with the judge's choice for best of show?

If you try to make paintings that please everyone, you will be inhibiting your own creativity and most likely repeating what has been done before. Recognize that viewers and artists are all different and that this makes everything possible.

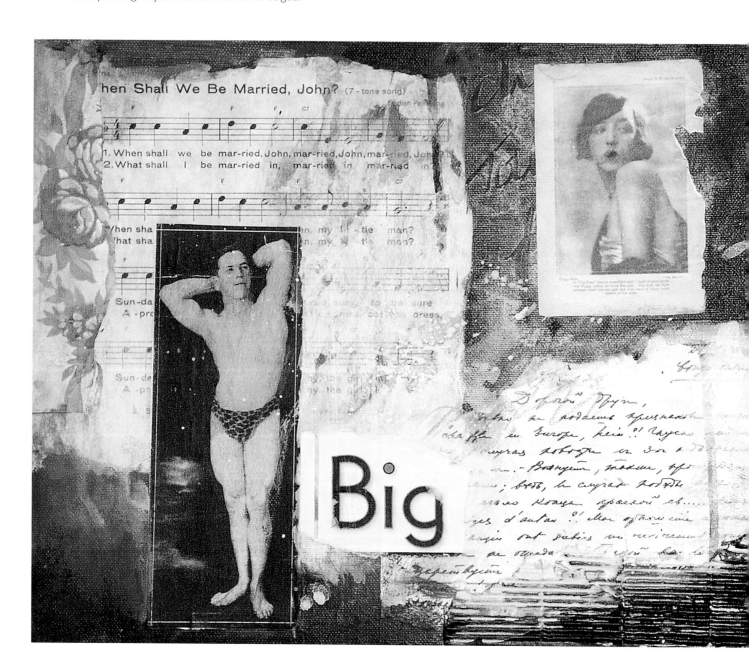

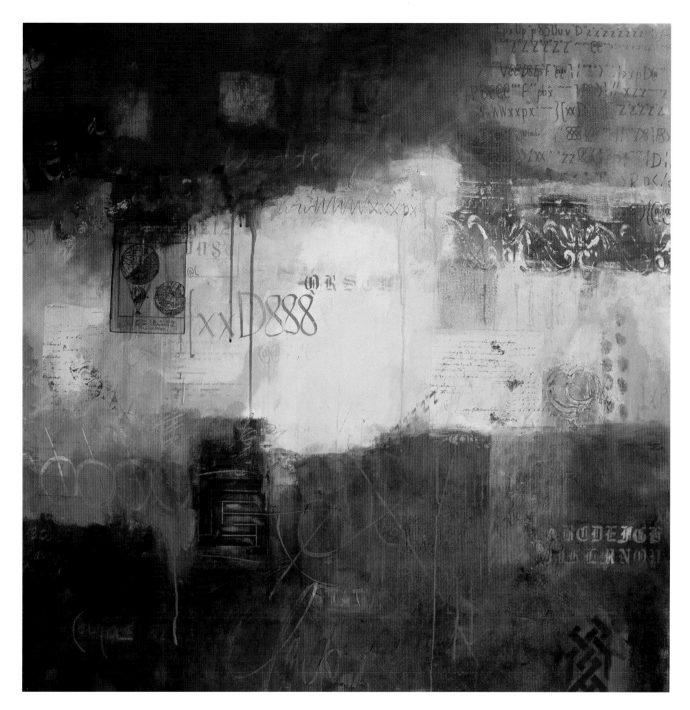

OPPOSITE: *Big John*,
Ann Baldwin, 12" x 16"
(30.5 x 40.6 cm), acrylic,
collage on paper. Private
collection.

*The big guy is a strong focal
point in a classic position.
The image has the greatest
contrast too. The woman at
the top has been covered
with a veil of translucent
paint to push her more into
the background.*

ABOVE: *Printer's Poem #3*,
Ann Baldwin, 48" x 48"
(121.9 x 121.9 cm), acrylic,
ink, collage on canvas.

*There's a lot going on here,
with multiple text marks,
stenciling, and scribbles. The
strong horizontal bands of
color give the piece order.*

Where to Begin?

A blank canvas or sheet of paper can be scary to some artists. If you're one of them, try starting a painting like this:

Cover the support with paint (one color, several colors, thin paint, thick paint, it doesn't matter)—anything to get rid of the blankness.

Grab a magazine, tear out random images or text, and stick them down on your support without any thought. Partially cover them up with a translucent paint like Titan Buff or Zinc White. Some of the darker areas will show through in intriguing ways, ready for the next layer.

Doodle on your sheet with a non-water-soluble thick crayon or colored pencil. Most of this layer will eventually be hidden, so be as free as you like, then cover your jottings with a glaze (a thin layer) of transparent paint. Even after you have added collage and more paint, a few tantalizing glimpses of this first layer may remain.

As an alternative to doodling, write random thoughts all over your support. Again use an insoluble medium such as permanent ink, colored pencil, or Caran d'Ache Neocolor I wax-oil crayons. Graphite can also work, but the softer the lead, the more likely it is to lift and mix with subsequent layers of paint. Be sure not to write anything too important or you'll find it hard to cover it up!

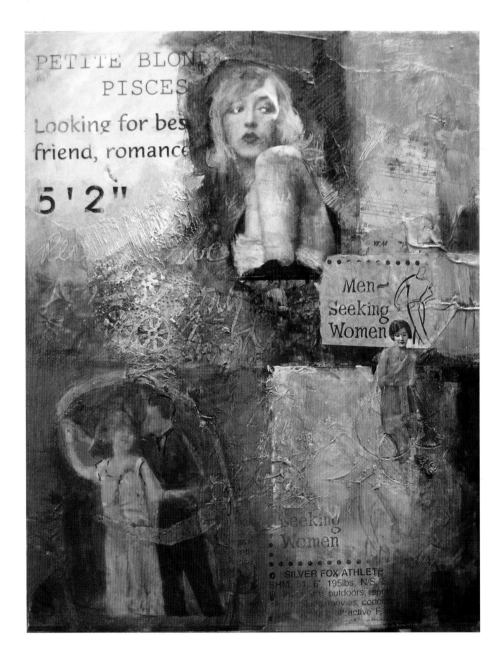

Men Seeking Women,
Ann Baldwin, 16" x 12" (40.6 x 30.5 cm), mixed media on paper. Private collection.

The largest image is in the very center at the top, but the other two images of people on either side of the lower half of the painting create a triangle or pyramid.

The curve of the gauze leads the eye up to the strip of corrugated cardboard.

This layout has a dual focus. The two portraits are linked by a diagram of the theater. Opposite corners contain text to maintain the balance.

Focal Point or Not?

Let's begin with the dangerous notion that you don't absolutely have to provide a single focal point. Many well-known artists in the past 100 years have done quite well without one. Jackson Pollock (flowing lines and drips), Willem de Kooning (thick brushstrokes in varied directions), Robert Rauschenberg (grids), and Sean Scully (repeated rectangles) have all produced work that encourages the viewer to roam around the entire painting without settling on one particular spot. In this style of "all-over composition"

each part of the painting is as interesting as every other part. Try some of these methods for yourself:

- Repetition of a shape and/or a color, providing visual "stepping stones." The more repetition, the stronger the rhythm, and the easier it is to follow the pathways.

- Flowing lines that glide across the canvas, double back, loop, streak, and overlap.

- Grids that divide the space into separate compartments, which nevertheless relate to each other.

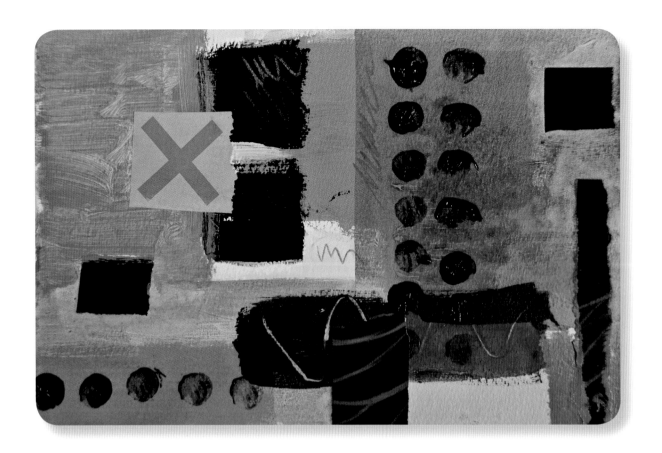

ABOVE: *The X marks a traditional focal point, but the repeated circles encourage horizontal and vertical movement through the painting.*

LEFT: *This piece is heavily patterned, but the grid provides a strong structure.*

RIGHT: *Astrolabe*, Ann Baldwin, 15" x 11" (38.1 x 27.9 cm), collage, crayon, stencil, acrylic on paper.

Circles naturally draw the eye, but this one is placed near the top. The stenciled frieze on the left-hand side takes the viewer to other parts of the painting.

Simple or Busy?

Some artists feel comfortable putting a lot of "stuff" into their paintings; others prefer the uncluttered approach. I admit to being a busy painter, but I also really appreciate the meditative quality of minimalism. Neither approach is the right way. It all depends on the effect you're aiming for. Say you are creating a collage as a memento of a lively family event like a fortieth birthday party. Chances are you'll want to re-create the atmosphere of it through the inclusion of several photographs, maybe some text, fragments of greetings cards, even snatches of some favorite music. You might add some diagonal lines to make it more dynamic. All this will result in a busy but energetic composition, which is appropriate to the occasion.

Now imagine that you are trying to re-create the mood of a peaceful afternoon by a lake. The more detail you include, the more you will disturb the peace. Horizontals would work: large, plain areas of cool color, smooth texture, simple shapes, nothing too geometric since this is a natural scene. Get the picture?

The bottom line: Know what mood you want to convey before you begin selecting your content.

tip

Sometimes you might have preserved one part of your painting for the wrong reasons. For example, you just love the color, even if it doesn't fit with the rest, or you have to have a circle in every painting, or those lines were so time-consuming to do you couldn't bear to erase them. Be bold; cover it up. You can always use the technique or idea in a future painting.

Symmetry or asymmetry?

Here in the West, where I live, symmetry is not popular in art. Art teachers will tell you not to place your focal point in the middle. I've even heard symmetry described as "boring." If it is a mindless mirroring of shapes on each side of the painting, this could be true. Again, you have to know why you're aiming for symmetry. Symmetrical paintings have perfect balance. Think of a mandala. The dictionary describes it as "a symbol representing the self and inner harmony." Symmetry doesn't have to be simple. If a symmetrical composition contains a variety of shapes, colors, and textures, it might be quite complex.

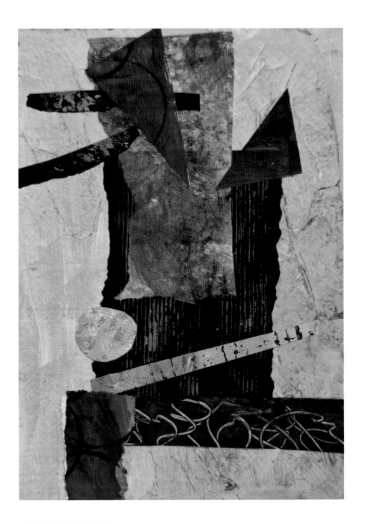

ABOVE AND OPPOSITE:
Moonrise #1, #2, #3,
Ann Baldwin, 11" x 6"
(27.9 x 15.2 cm) each,
hand-painted papers
on watercolor paper.

Asymmetry exists when one side of a painting does not mirror the design of the other. It does not necessarily mean the piece is unbalanced. In fact, Japanese ikebana demonstrates very well how harmony can be achieved even when a composition is lopsided. Asymmetry is the type of balance or intentional unevenness characteristically found in Japanese art where it is called hacho. When an asymmetrical design is disturbingly off-balance, the result is disharmony. If disharmony is what you are aiming for—as in an artistic statement about the horrors of war, for example—then this is one way to achieve it.

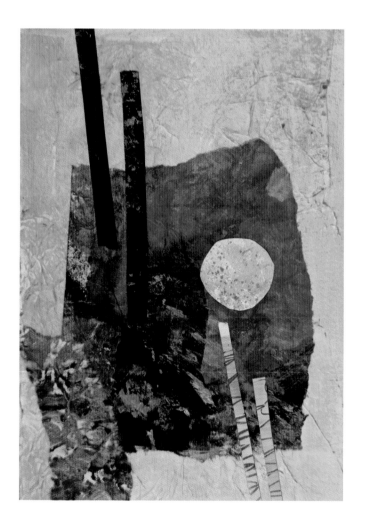

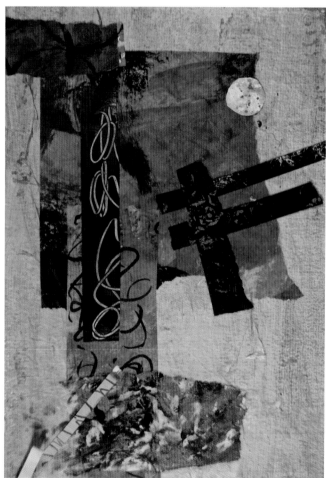

Horizontals, Verticals, and Diagonals

Verticals suggest strength and stability. Strong manmade objects we see regularly are telephone poles, towers, columns, steeples, skyscrapers. In nature we recognize the stability of a straight tree trunk or a tall sunflower. Horizontals are less dramatic, more predictable, as the horizon itself. We expect the water in a lake to be flat, the floors in our homes not to slope, dinner plates to have flat bases, and mattresses not to tip us out of bed. There is comfort in the horizontal in art. Diagonals when attached to verticals can add to their strength, but otherwise they take us outside our comfort zone. This can be positive or negative. Think of the exhilaration a skier feels when faced with a snowy slope, or a surfer riding the waves—or, conversely, the fear in the pit of your stomach as you descend that steep hiking trail. Diagonals bring energy and excitement to paintings.

WHY IS MY PAINTING BORING?

Here are some possible reasons:

- There's very little going on.

- There's too much repetition—of brushstrokes, similar-sized shapes, same color, lines in the same direction.

- It is lacking in originality—the subject is a cliché, it's been done too many times before, or the style is a copy of someone else's.

- It looks exactly like everything else you paint.

- It is technically clever but has nothing to say.

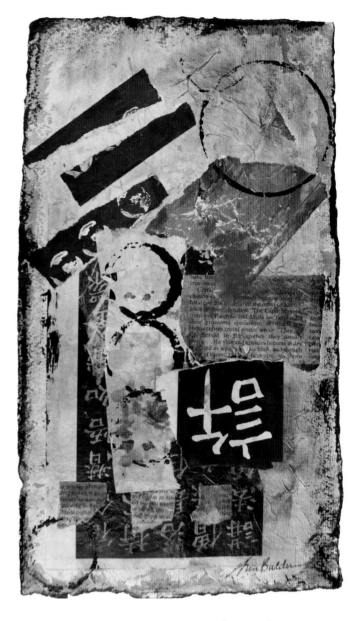

Conversation,
Ann Baldwin, 15" x 6" (38.1 x 15.2 cm), acrylic, painted papers on Indian handmade paper.

The long, narrow sheet of paper gives this piece a predominantly stable, vertical orientation. The three diagonals add some dynamism.

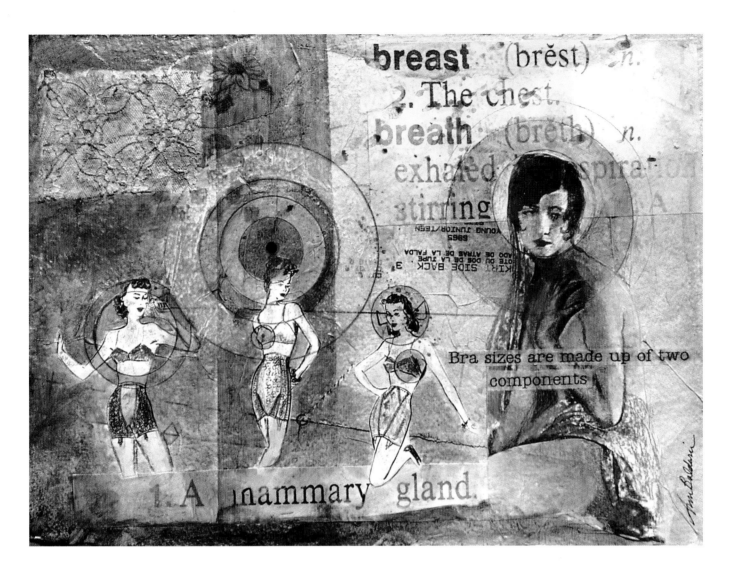

How Do You Know When a Painting is Finished?

This is a hard one to answer, because only the artist really knows. Someone may tell you "Stop! It looks great the way it is," but if you don't feel satisfied, then it is not finished. You may have had a particular idea in mind when you started and feel that you have not yet communicated it. Then is the time to look at the elements of composition and decide whether they are working for or against your original concept.

Sometimes you have to let go of your own prejudices and accept the way a piece has turned out, particularly if it gets a good response from others.

How many times have you struggled over a particular section of your painting and, as a result, felt that people can sense that struggle and see it as failure? Only you know

Waiting to Exhale,
Ann Baldwin, 15" x 22"
(38.1 x 55.9 cm), acrylic,
collage, crayon on paper.
Private collection.

This painting may appear quite complex, but it required very little work after gluing down the collage—a couple of thin glazes of paint, circles drawn with a compass round the faces, and some coloring of the clothing with Caran d'Ache.

your painting's history, so don't allow it to cloud your judgment. Through X-rays we now know that some of the greatest paintings in history were reworked many times by the artist.

Do the size and shape of your support suit your composition? If not, consider cropping. If this is not possible, try the painting again on a new support, or turn it into a diptych!

Don't make hasty judgments about the success or failure of a painting. When you can't think of anything else to do, put the piece away for a week or even longer. Seeing it again with a fresh eye will help you to judge it more objectively. I am surprised how often I appreciate one of my "unfinished" paintings months after I stopped work on it.

Here are some quick tips for painting composition:

KEEP IT LIVELY

- Vary the size and shape of your collage pieces.
- Make bright colors "pop" by surrounding them with neutrals.
- Provide plenty of contrasting lights and darks.
- Include diagonals.

HOOK YOUR VIEWER

- Obscure some areas, "veil" others, and emphasize the most important.
- Provide "pathways for the eye": Use curved or straight lines to lead from one place to another; repeat a color in different places so that the eye is encouraged to skip from one area to the next.

- Combine photos with hand-drawn marks, even creating your own graffiti.
- Repetition is effective, but don't let it become mindless. Break the rhythm every now and then. Repeat an image, but alter it subtly in color, size, or orientation.

PLAYING IT SAFE

- Don't place large distracting shapes at the edges.
- Keep a balance between lights and darks (values).
- Avoid too much detail that might compete with your main image.
- Keep color harmonious—cool or warm.
- Take care that heavy textures don't create distracting elements.
- Keep "heavier" objects near the bottom of the paper.

tip

"Hide" a painting somewhere in your house where you will come across it unexpectedly. In the split second that you see it again, you will be able to judge it more objectively.

RIGHT: *Prisoner of Time*, Ann Baldwin, 8" x 5" (20.3 x 12.7 cm), acrylic, collage, oil pastel on paper.

This piece looks nothing like my original plan. At the last minute I added the images of the book covers to hide the muddle underneath. It actually strengthens the composition by balancing the right side with the left.

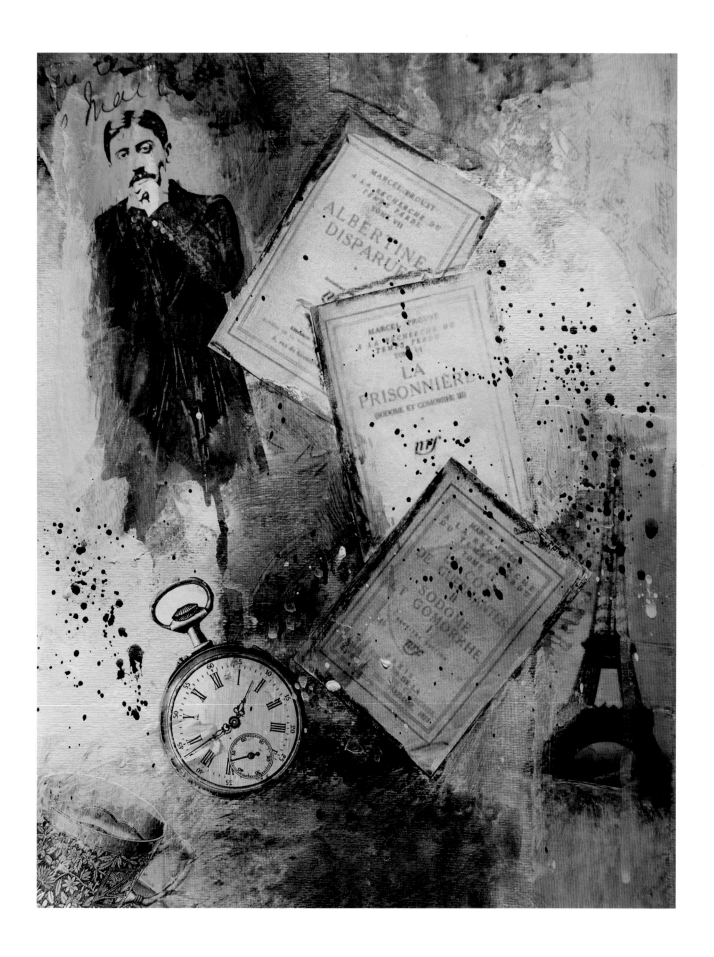

Chapter 3

Approaches to Abstract Design

Small children playing with paint do so with little regard for how their paintings will turn out. They revel in the process, exploring the flow of the paint, the twirl of the brush, the way the colors mix, and how the shapes and lines overlap. Abstract painting enables us to be children again and allow our right brains to take over. Have you ever experienced a creative block? If so, get into the "abstract zone." Have you ever felt a mismatch between your left-brain concept and your technical skill? Grab a piece of paper, any brush, and two or three pots of paint and let your instincts guide you.

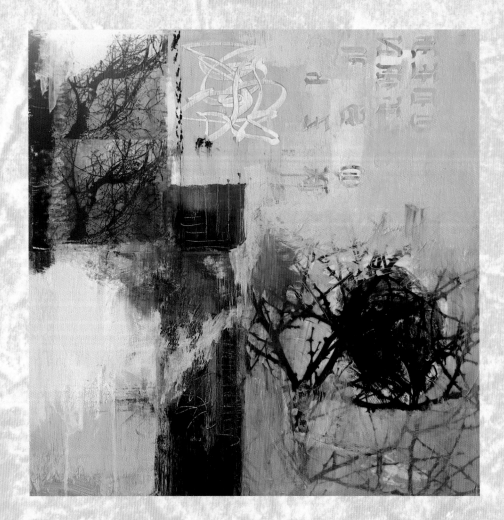

Nesting Point II,
Ann Baldwin, 18" x 18"
(45.7 x 45.7 cm), ink, digital
photographs, oil pastel,
acrylic on birch panel.

What is Abstract Painting?

Abstract adjective /abstrakt/ **1** theoretical rather than physical or concrete. **2** (of art) achieving its effect through color and shapes rather than attempting to represent recognizable reality. *(Oxford Compact Dictionary)*

In other words, your painting doesn't have to look like anything recognizable. It can be simply made up of shapes, lines, colors, and/or textures. Abstract painting sets you free! No need to be able to draw or write. You can go with the flow like Jackson Pollock. You can plan the whole thing with meticulous accuracy like Piet Mondrian. Or go for the naïve style of your inner child.

Abstraction allows you to express your personality. You're a lively, happy-go-lucky dancer? Get out those big brushes, brightly colored paints, and make sweeping gestural strokes over your blank canvas. You're a cautious, controlled, neat-freak? Pencils, pens, rulers, small brushes, and not-too-thick and not-too-fluid paints may be more inside your comfort zone.

Whatever kind of person you are, your feelings can change from day to day. Express your mood of the moment—anger, joy, peace, sorrow—in your choice of colors, textures, shapes, and quality of line.

Abstract art is also a wonderful way to re-create memories, sad or happy. After a particularly difficult time in their lives, some people turn to art to work through their problems. Art is a medically accepted form of therapy.

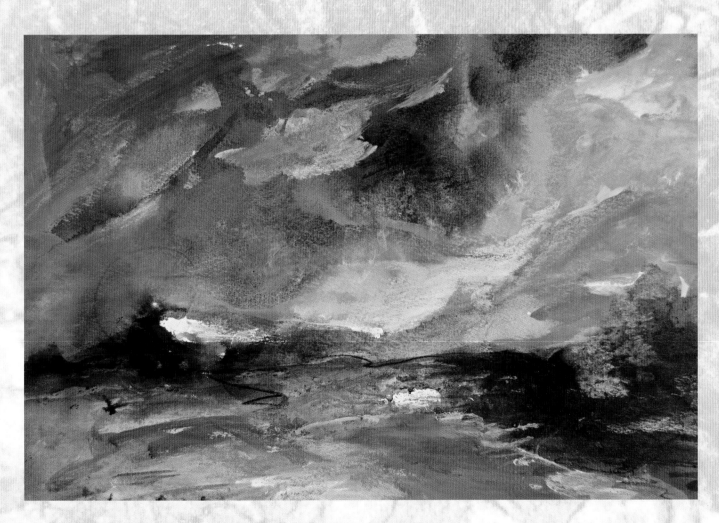

El Niño, Ann Baldwin, 11" x 14" (27.9 x 35.6 cm), acrylic, pastel on watercolor paper. Private collection.

The title gives a clue to the intended subject: a stormy day. Swirling brushstrokes, ragged shapes, lurid colors, and lack of structure help to give the impression of nature's chaotic forces.

Where to Begin?

Getting started on an abstract painting can seem hard at first. After all, you're not simply going to reproduce an object or scene in front of you. It all has to come from your imagination. You could start with a simple vision then jot down types of media and ways of using them:

Vision: A bright breezy summer's day.

Approach: What colors could you use to express it? Primary blue and yellow with a touch of pastel pink, perhaps. Which media? Juicy acrylic paint, torn scraps of rice paper in random shapes and sizes, light decorative crayon lines might work.

Without using actual objects, brainstorm "recipes" for some of these:

- A cozy evening by an open fire (warm colors, strong contrasts, soft shapes?)

- A walk on a rainy night

- An argument with a relative

- Your favorite meal

- A special piece of music (listen to it while you create!)

- Dancing in a field of flowers

- A migraine headache (ouch!)

- The loss of a loved one, human or pet

- Farmer's market (the colors, the movement)

- An arduous climb up a mountain

- Swimming in a calm sea (stay with the horizontal)

- Walking barefoot over broken glass (well, you don't have to do it—just imagine!)

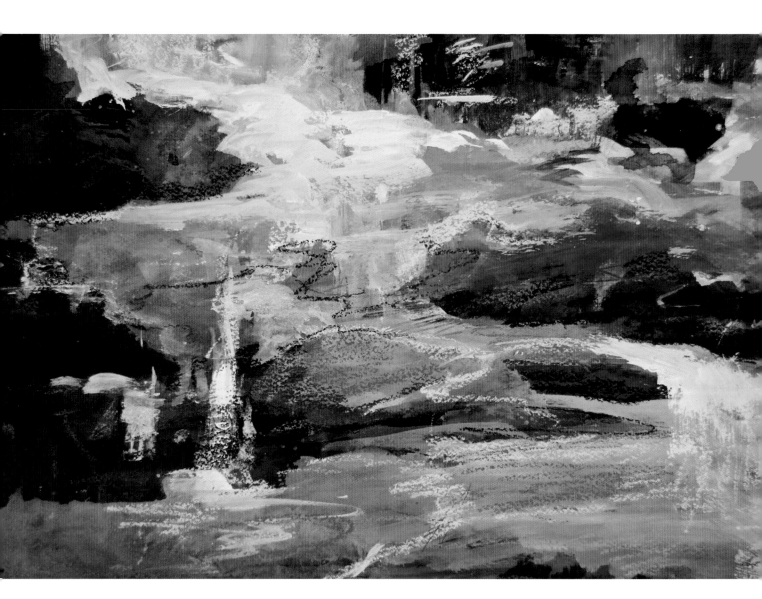

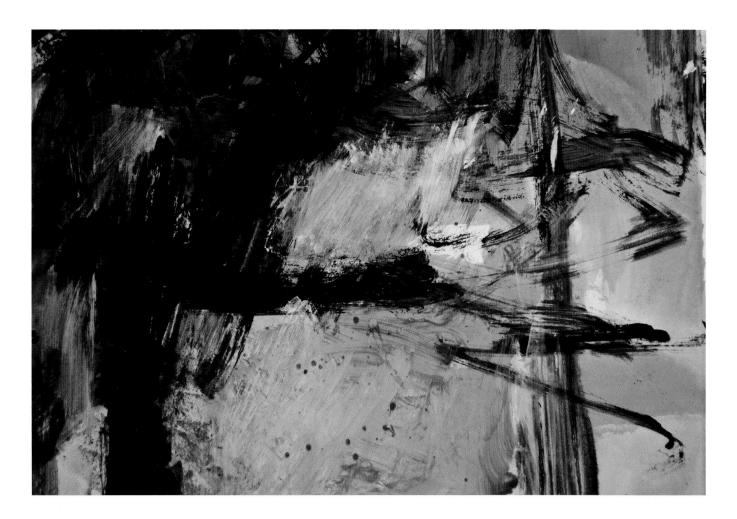

OPPOSITE: *Mountain River*, Ann Baldwin, 11" x 14" (27.9 x 35.6 cm), acrylic, crayon on rough water-color paper.

Flowing, curvilinear strokes, cool colors, and superimposed lines combine to suggest an icy, rushing river. Even the rough texture of the paper contributes to the mood.

ABOVE: *Anger*, Ann Baldwin, 9" x 14" (22.9 x 35.6 cm), acrylic, oil pastel on hot press paper.

Even if you didn't know the title, you would probably guess that the broad, bold brushstrokes and strongly contrasting values are trying to convey strong emotion. The use of deep black and the hot reds may add negative overtones.

The Elements of Composition

Your imagination knows no bounds when it comes to abstraction. Sometimes, though, a viewer will interpret your painting quite differently from the way you intended. Does it matter? Only you can be the judge of that. But if you really want to communicate a particular mood or idea, you should gain some understanding of how the various elements in a painting can be controlled to re-create that mood or idea. First, it can help to be aware of the main elements of composition: color, shape, line, and texture.

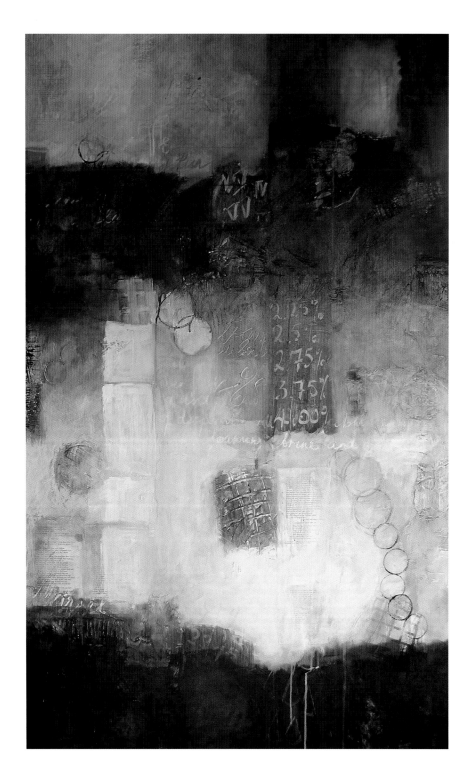

tips

In order to judge your values, squint. Partially closing your eyelids minimizes the color and emphasizes darks and lights. Alternatively, look at your painting through a piece of green or red cellophane. This will tend to exaggerate the value contrasts, but it can help you to judge the balance of your composition.

To make a bright color really pop, surround it with neutrals. The contrast in saturation helps to draw attention to it.

Sequential, Ann Baldwin, 60" x 36" (152.4 x 91.4 cm), mixed media on canvas.

This is an example of a painting with strong value contrasts. Although some areas are almost black (low key), a large area consists of very light colors. The reds are mid-values.

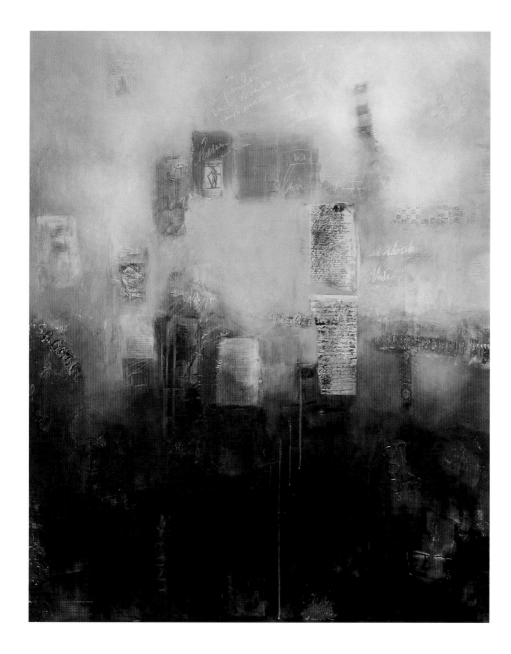

Found Document II,
Ann Baldwin, 60" x 48"
(152.4 x 121.9 cm),
mixed media on canvas.
Private collection.

The hues in this painting are Dioxazine Violet, Alizarin Crimson, Utramarine Blue, Paynes Gray, Titanium White, and Titan Buff. Though red is usually a warm color, crimson has a touch of blue. Together with the other blues and the cold white, this creates a cool temperature. Only the crimson is highly saturated. The dark values are in the lower part of the canvas, adding weight to the composition. The very light values near the top create airiness and a sense of space.

COLOR

Each color has a hue, which is its name (e.g., Cadmium Red, Chromium Green, Yellow Ocher, or Ultramarine Blue).

The hue also has a value, or degree of darkness (low key) or lightness (high key). For example, most shades of yellow are high key.

Each color also possesses a certain degree of intensity, a level of saturation from dull to brilliant.

Colors have temperatures from warm reds to cool blues on the color wheel. Of course, there are cool reds with a touch of blue and warm blues with a touch of red. Cool yellows have a touch of green and warm yellows are closer to orange. Want to create an atmosphere of calm? Stay on the cooler side of the color wheel. Need to add some excitement? Go for the "hot" colors!

Lastly, colors may also carry emotional connotations, which differ according to culture. In the West black is the color of mourning, whereas in India it is white, and in Iran it is blue. In the West yellow stands for cowardice, yet in Japan it means courage. This originated from the practice during the War of Dynasty in 1357 of each warrior wearing a yellow chrysanthemum as a pledge of courage.

SHAPE

Shapes can be either positive or negative. Positive shapes are those that have been intentionally created against a background. Negative shapes are the ones left behind between the positive shapes. Both are equally important.

Shapes can be organic or geometric. Organic shapes are more freeform, whereas geometric shapes are mathematically derived.

Shapes can attract more attention if you vary size, style, and orientation.

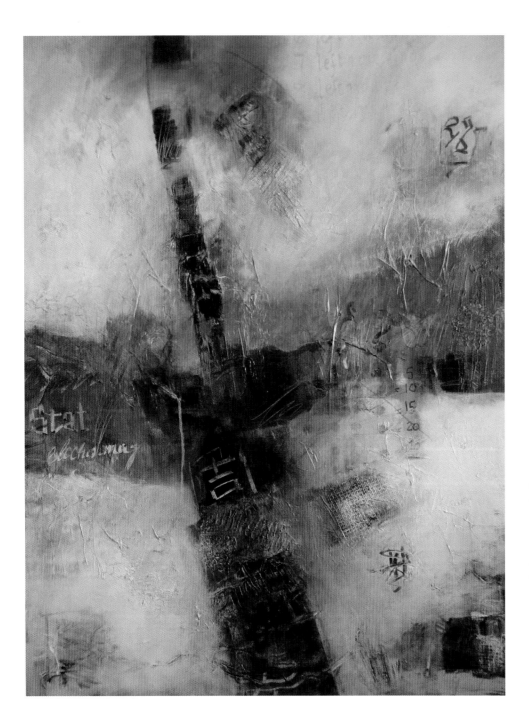

Signs and Symbols II, Ann Baldwin, 40" x 30" (101.6 x 76.2 cm), acrylic, tissue paper, ink on canvas. Private collection.

In this painting the positive shape is a dark cruciform. Because it touches all four edges of the canvas, the four light-colored areas left behind are negative space. However, they form clear shapes of their own, which carry equal importance in the overall design.

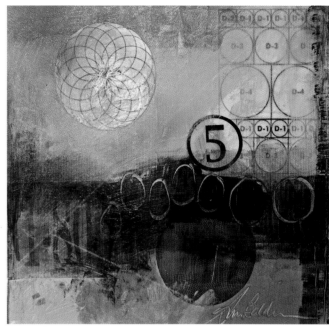

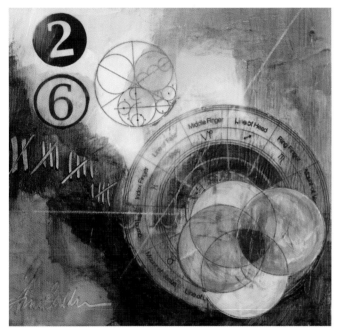

CLOCKWISE: *37 Count*, Ann Baldwin, 12" x 12" (30.5 x 30.5 cm), acrylic, collage, ink on canvas.

Cycles #26, Ann Baldwin, 12" x 12" (30.5 x 30.5 cm), acrylic, collage, ink on canvas.

Circles #5, Ann Baldwin, 12" x 12" (30.5 x 30.5 cm), acrylic, collage, ink on canvas.

In all of these pieces, shape is the dominant feature. Circles appear as outlines, solid, or overlapping. Some are perfect; others are distorted. Some have numbers inside them; others have words. Despite their simplicity, the variety of sizes and treatments makes the paintings interesting.

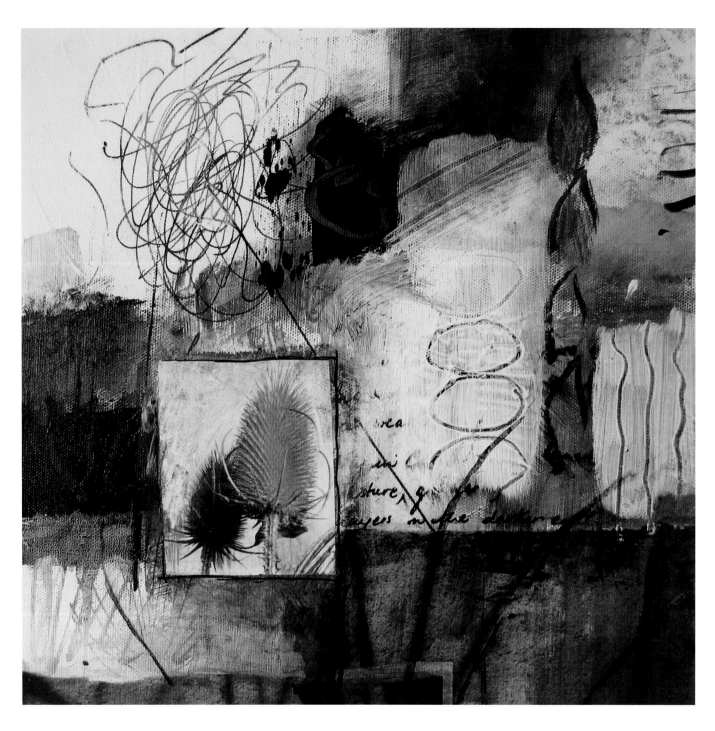

Windborne, Ann Baldwin,
12" x 12" (30.5 x 30.5 cm),
ink, digital photograph,
acrylic on canvas. Private
collection.

*Many of the shapes in this
painting are repeated to
create rhythm and pattern.
The circles, leaves, reeds,
and obviously the thistle are
organic shapes. These are
in contrast to the geometric
shapes of the rectangles.
Originally the entire canvas
was painted white. The areas
of white still showing become
negative shapes, whereas the
deliberately drawn shapes
are positive. Most of the
shapes are either vertically
or horizontally oriented, mak-
ing a loose grid, which gives
the painting structure.*

LINES

Lines can be curved or straight and can be used to divide space. Contour lines help to define shapes.

Lines can bring energy or stability to a design. Stability is more likely to be achieved through the use of horizontal or vertical lines. The bolder they are, the stronger they'll be. The diagonal lines used here are dynamic. Broken lines may be "filled in" by the viewer, creating pathways.

Lines may be gestural (spontaneous and loose) or deliberate (planned and structured). Here the lines of the roofs and the telephone poles are planned, whereas the lines in the scribbled area are entirely spontaneous and disrupt some of the order to add energy to an otherwise static painting.

Shadows Slanted,
Ann Baldwin, 24" x 48"
(61 x 121.9 cm), ink,
photo-graphic collage,
acrylic on canvas.

The digital images of shadows on a patio display line to define the shape of the objects they reflect—in this case, it was a decorative patio table.

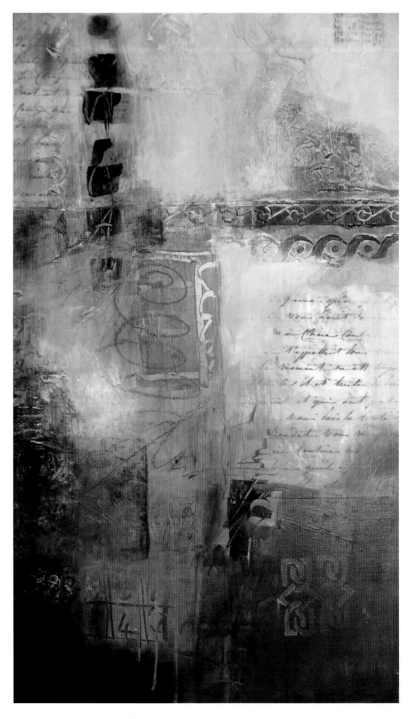

ABOVE: *Shadows I*,
Ann Baldwin, 36" x 18"
(91.4 x 45.7 cm), ink,
digital photographs, oil
pastel, acrylic on canvas.
Private collection.

RIGHT: *Deux Lettres*,
Ann Baldwin, 36" x 18"
(91.4 x 45.7 cm), ink,
collage, crayon, acrylic
on birch panel. Private
collection.

*Here the vertical row of
black rectangles is read as
a bold line leading the eye
down to the lower art of
the painting.*

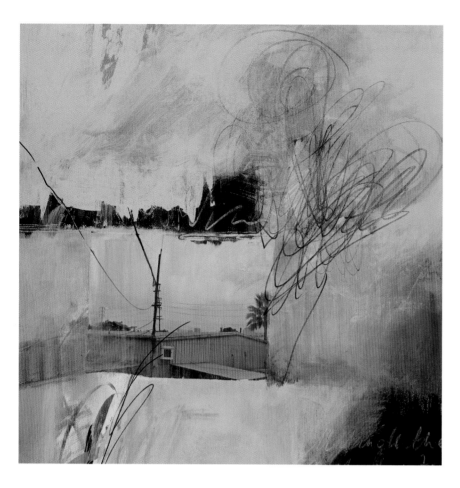

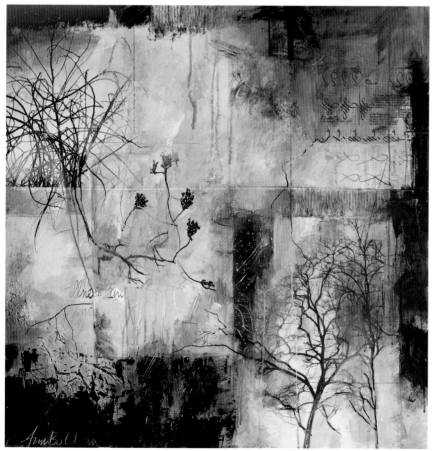

TOP: (detail) *Skylines II*, Ann Baldwin, 36" x 18" (91.4 x 45.7 cm), ink, graphite, digital photographs, acrylic on canvas.

BOTTOM: *A Stillness and a Silence*, Ann Baldwin, 36" x 36" (91.4 x 91.4 cm), acrylic, digital photographs, tissue paper, ink on canvas.

Some abstract paintings do contain recognizable objects, but they may be greatly simplified, distorted, or taken from their normal context. Photographs of the bare branches of trees in winter are reduced to a mere tangle of lines in this painting.

TEXTURE

Texture ranges from rough to smooth. Roughness creates animation and energy. Areas of smoothness can provide resting places for the eye.

The words we use to describe texture—soft, hard, creamy, jagged, uneven, bumpy—carry emotional connotations.

A canvas was covered with a rough layer of light modeling paste for a textured base.

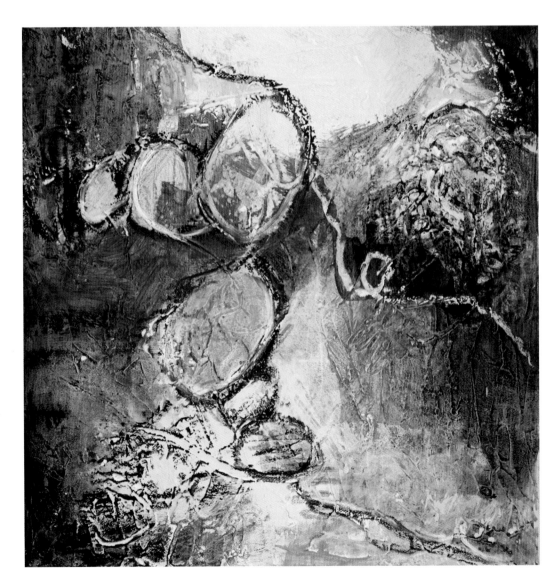

Evidence, Ann Baldwin, 12" x 12" (30.5 x 30.5 cm), modeling paste, oil pastel, acrylic on canvas.

The organic character of the final painting relies on the texture. Oil pastels were used to make the rings, which wind their way through the painting, creating a visual pathway through the rough terrain.

Judging Composition in Abstract Painting

Composition in abstract painting can be tricky if the shape is in the wrong place. There is no content to distract the viewer. However, often representational painters will cause an unimportant object in, say, a still life to assume too much importance by placing it in an awkward position, using a jarring color, or giving it too much pattern or texture. This will distract the viewer from the intended focal point. Imagine a serene still life of roses with a carefully rendered can opener in one corner of the painting. Make sure your "can opener" is your intention!

WHAT CREATES A FOCAL POINT IN AN ABSTRACT PAINTING?

This is a purely perceptual experience. The eye is drawn to a particular feature, because it dominates in some way. It may be:

- The largest shape
- The brightest (and most highly saturated) color
- The most or least textured area
- The area with the strongest value (light versus dark) contrast
- The only cool color among the hot ones
- The only hard-edged shape

Remember, only one of these features can be enough to draw the viewer's eye. It is unnecessary to use all of them. Look at van Gogh's *Irises*. There are only a few white ones among the predominant blues. They are the same shape and size texture and are painted in the same style, but they are the lightest value in the painting, so they draw attention to themselves.

MAKING EVERY PART OF YOUR PAINTING WORTH LOOKING AT

If your aim is to provide a painting with a focal point, you must also make sure that the rest of the piece is worth exploring. You can create subtlety with layers, partially obscured shapes, and lines. Add small, perhaps paler, shapes that echo the dominant shape. If the focal point is heavily textured, have other areas of lesser texture that are nevertheless interesting. Experiment with neutrals which have undertones of color.

BE YOUR OWN CRITIC

Some questions to ask yourself about the design of an abstract painting. Be aware that they won't all apply to every painting.

- Are the colors sufficiently interesting to keep the viewer's attention? Have you included enough variety? Even a relatively monochromatic painting can have a wide variety of shades of a color.

- Does it have good value contrasts? Is the greatest contrast where you want your center of interest?

- Have you contrasted textures in order to draw attention to them?

- Are your brushstrokes varied in size and direction to animate the surface?

- Have you included a variety of shapes? Do you want one to dominate? If so, is it large enough?

- If you have used lines, do they vary in thickness?

- Have you varied your edges? Or are you deliberately going for a hard-edged or soft-edged look?

- Does the work hold together as a unit—through color harmony and shape repetition?

- Assuming you were aiming for balance, does the painting seem unbalanced, one aspect dominating with no counterbalance? For example, a large shape in a neutral color might need to be balanced by a small touch of a bright color.

Step-by-Step Painting

This project takes you through the different steps involved in creating a layered abstract painting. It makes use of textured and photocopied collage elements, as well as stencils and fluid acrylic paint.

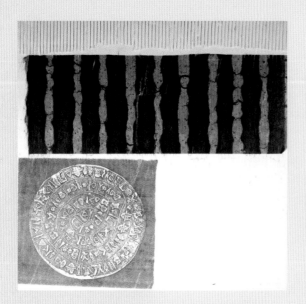

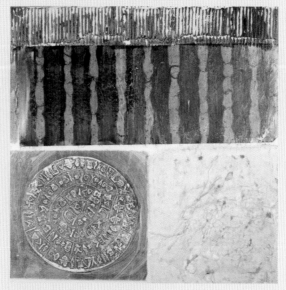

1 A pre-gessoed canvas has been collaged with a piece of striped Indian hand-printed paper, a photocopy of the Phaistos Disc, and a piece of corrugated cardboard.

2 A piece of crumpled rice paper has been glued on bottom right, and then painted with a thin glaze of Transparent Yellow Iron Oxide. The corrugated cardboard has been given a glaze of Quinacridone Crimson, and the rest of the collage has been covered in a thin layer of Zinc White, which is translucent. This gets rid of the rather dead photocopy black.

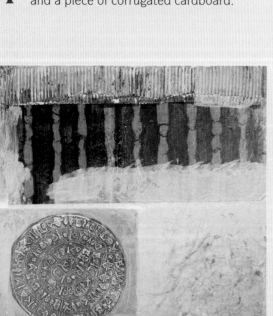

3 Titan Buff has further lightened some of the collage.

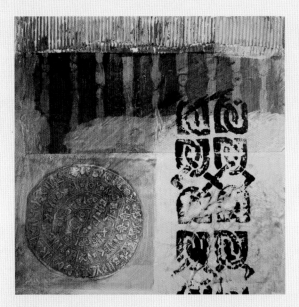

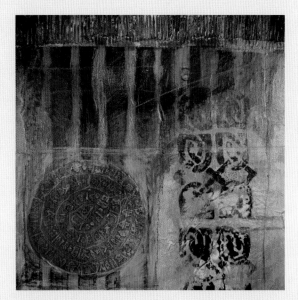

4 A foam stencil has been used to stamp a decorative pattern on the right. Another layer of Quinacridone Crimson has been added to the left side.

5 The black stripes have been continued with paint farther down the painting. A glaze of Transparent Yellow Iron Oxide covers the entire canvas. Quinacridone Burnt Orange has been added to the Phaistos Disc to emphasize it.

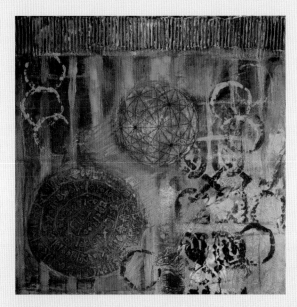

6 A new piece of collage—a geometric diagram of a sphere—helps to balance the composition by overlapping some of the other elements. Yellow Caran d'Ache wax-oil crayon has been used to highlight the spaces between the black stripes.

LEFT: *Codes*, Ann Baldwin, 12" x 12" (30.5 x 30.5 cm), mixed-media collage on board.

Experiments in Texture

Mixed-media paintings often contain textured materials. Cheese-cloth, netting, tissue paper, canvas, string, corrugated cardboard, rice paper, lace, paper doilies, screen netting, paper towels, coffee-cup holders, handmade papers of many kinds, and crumpled newspaper all work well in layered paintings. Some artists attach small objects such as keys, beads, nails, springs, Scrabble letters, jigsaw puzzle pieces, buttons, metal tags, badges, leaves, twigs, seeds, pasta, paper clips, dice, typewriter keys, watch parts, plastic discs, bottle caps, and rivets to their work.

LEFT: *Script #14*, Ann Baldwin, 15" x 11" (38.1 x 27.9 cm), acrylic, ink, collaged text, corrugated cardboard, modeling paste, heavy gel on Indian handmade paper.

OPPOSITE: *Calculations*, Ann Baldwin, 24" x 18" (61 x 45.7 cm), acrylic, modeling paste, heavy gel medium, newspaper, collage on canvas.

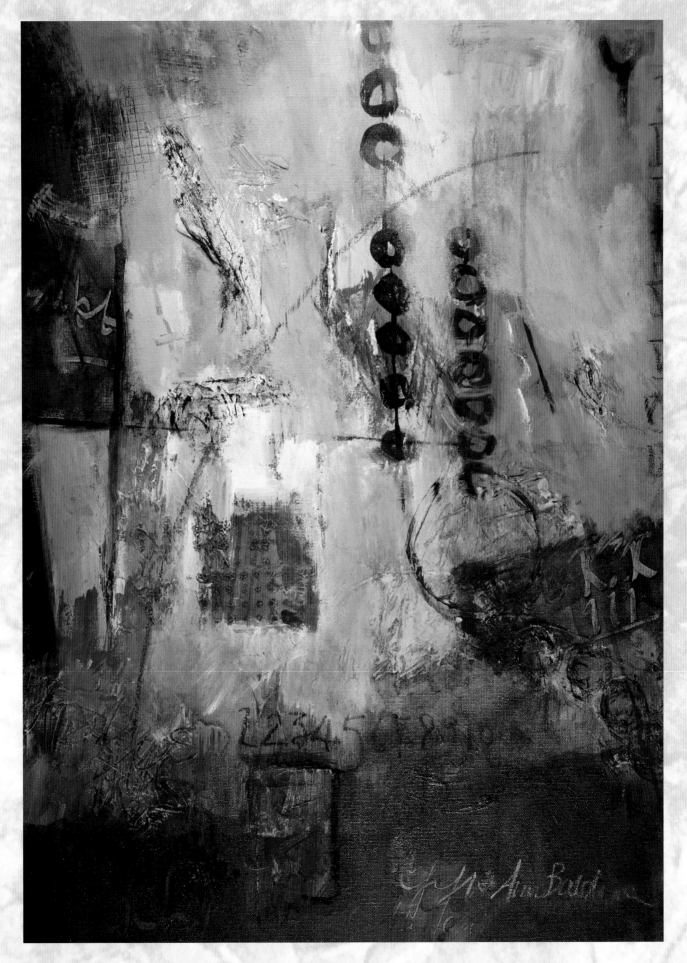

Materials for Creating Texture

It is important to recognize that textures form a vital part of the composition. The more prominent the texture, the more likely it will become either a focal point or a distraction. The addition of texture to a plain painted area can bring it dramatically to life, but it also needs to be integrated into the composition as a whole. There are many ways to do this, depending on the nature of the collage material.

Some textured materials are translucent when covered in matte medium. This makes them useful for veiling what lies beneath, adding a touch of mystery.

DETAIL OF PAINTING BELOW: *The wispy strands of torn cheesecloth form subtle lines on the painted surface.*

BELOW: *Dreamer*,
Ann Baldwin, 11" x 15"
(27.9 x 38.1 cm), mixed
media on paper.

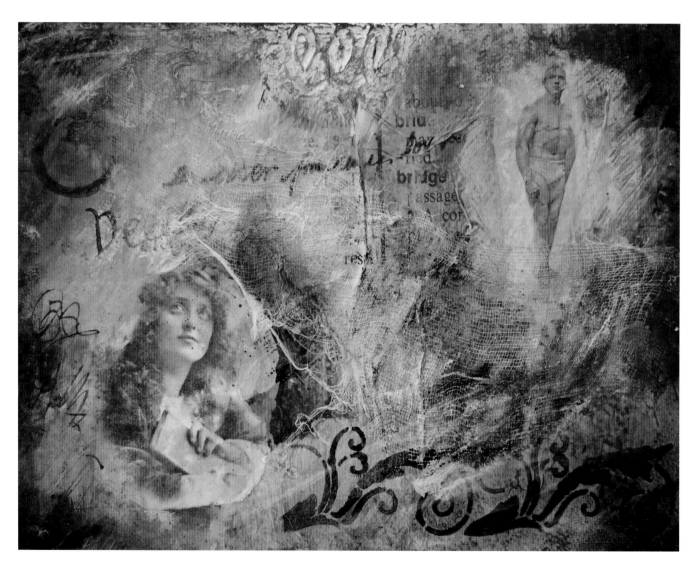

CHEESECLOTH

You can find cheesecloth in grocery stores where it is sold for use as a strainer in cooking. It was originally used to strain cheese. You can also buy it in home improvement and fabric stores. The weave may be coarse or fine. It is usually white or a natural off-white and it is highly absorbent. This is an advantage if you want to dye it.

You could also collage cheesecloth in its raw state directly onto your art. It can act as a veil through which details will be only partially visible. Apply plenty of matte medium directly to the painting surface, then slide the cheesecloth around until you find the right position. When the medium is dry, you can run a transparent glaze of fluid acrylic over the area, integrating the fabric with the background.

Or, if you want to create contrast, when the glaze is dry, load the side of a flat bristle brush with a darker or lighter opaque tube or jar acrylic and brush it gently over the raised areas of fabric.

SCREEN NETTING

If you ever need to replace your window screens yourself, you'll likely end up with a lot of netting left on the roll. This can easily be cut into small rectangles and collaged to a painting with matte or gel medium. Since it is generally dark in color, the effect is more dramatic over a light background. It's surprising how often you can quiet down a busy area by adding a small square of gray netting. It doesn't even have to be painted.

DYEING CHEESECLOTH

In a shallow tray, mix approximately one part fluid acrylic or acrylic ink with five parts water.

Soak a piece of cheesecloth in the paint for a few minutes.

When the fibers have absorbed the paint, hang the cheesecloth up to dry. Lay down newspaper to catch the drips.

Have a dyeing session, mixing several pots of paint in different colors. You will then have a variety of colored cheesecloth to choose from and it will be easier to match them to a particular painting.

TISSUE PAPER

Tissue paper is an inexpensive and versatile collage material. It can be used to create a lightly textured first layer, which can then be painted with transparent fluid acrylic. First cover the support with a layer of matte medium. While this is still wet, lay down the tissue paper, manipulating it to form creases. Avoid bunching it up or it will disintegrate when you try to paint on top of it. Regular white tissue paper works best. Avoid colored tissue, as it is usually dyed and the colors will run.

Because tissue paper dries translucent, allowing some but not all of the light to pass through it, you can use it to great advantage to add mystery to your mixed-media paintings. If an area of text is too bold, calm it down with a covering of tissue.

RICE PAPER

Rice papers come in many different textures and weights. For the purposes of integration, white rice paper works best, as it can be painted in any color after it has been stuck down. The thicker the paper, the more opaque it will be even after it is covered with matte medium. Many papers contain strands of silk, which absorb the paint more readily, leaving the fibers darker than the rest of the paper. These papers, though harder to tear, can leave wonderful, ragged edges when ripped apart.

Like cheesecloth, rice paper can be dyed in advance by dipping it into a solution of diluted paint and hanging it up to dry. Afterward, the papers can be further embellished by lightly brushing thick gold paint over the raised areas.

Other texture materials are opaque and therefore less subtle. They will give complete coverage. The more prominent the texture, the more carefully their placement needs to be planned.

CORRUGATED CARDBOARD OR PAPER

Light bulb packets are often lined with stiff white corrugated paper that is perfect for painting. Since one side is smooth, it also adheres easily. Of course, there are dozens of other sources of corrugated cardboard in packaging materials. What a great way to recycle! If the cardboard is thick and brown, stick it down with heavy gel medium and then coat it with regular matte medium to act as a seal. When you come to paint it, the paint will stay on the top and not be absorbed into the fibers. For drama, try painting it first with a dark color then adding a light opaque or metallic paint to the ridges.

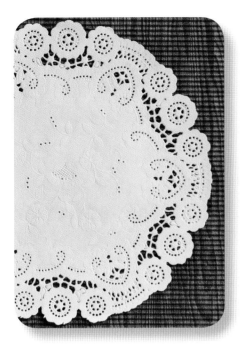

PAPER DOILIES

These come in several different patterns and colors. For easier integration, choose white or light-colored paper doilies. They can then be painted any color to harmonize with the rest of the painting. Fragments of a doily are often more intriguing than the whole thing.

EMBOSSED WALLPAPER

Pick up samples or small frieze rolls at a home improvement store. They come in a variety of patterns that make wonderful decorative elements in a mixed-media painting.

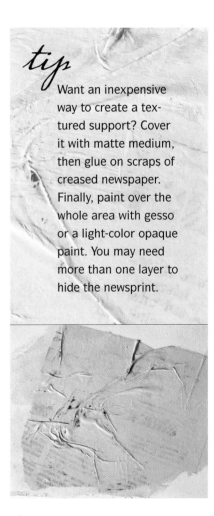

tip

Want an inexpensive way to create a textured support? Cover it with matte medium, then glue on scraps of creased newspaper. Finally, paint over the whole area with gesso or a light-color opaque paint. You may need more than one layer to hide the newsprint.

Creating Texture with Acrylic Mediums

There is now a wide range of mediums which can be used on their own or added to paint to give it more texture. Some, like Golden Heavy Gel and Golden Extra Heavy Gel, dry clear. Others, like Modeling Paste or Light Modeling Paste, are opaque white. Because they contain polymer most take a while to dry. A hair dryer tends to dry only the surface skin, leaving the layer beneath still soft. This can play havoc with your brush when you try to paint over it.

It works better to leave the medium to dry naturally over the course of an hour or so, depending on thickness. Meanwhile be prepared to work on a different painting. Golden Light Molding Paste, however, is full of tiny air pockets, so it dries much faster. It also absorbs the paint quickly, darkening it. A pre-coat of regular matte medium will act as a sealant, allowing a glaze to be added more predictably. Garnet or pumice gels contain granules, either fine or coarse, in a polymer base. Micaceous Iron Oxide has a texture like sand. The polymer dries clear, leaving the granules dark.

Bring out the rough texture of garnet or pumice gel by allowing the medium to dry, then applying a fairly thick, light-colored opaque paint that just catches the peaks of the granules. The effect is like that of a rough stucco wall.

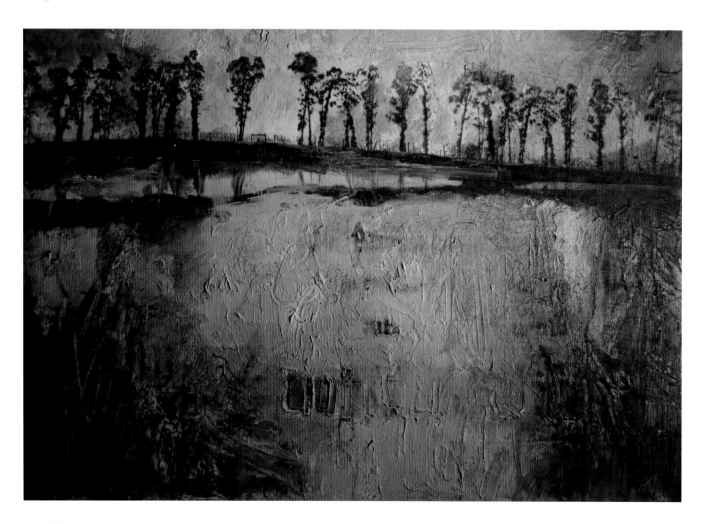

Making Patterns with Acrylic Mediums

The thicker texture mediums can be very successfully imprinted using a variety of objects: corks, bubble wrap, plastic mesh sheets, the side of a credit card, cardboard cylinders, embossed wallpaper, plastic netting, and rubber stamps (wash off immediately after use!). Some plastic food trays have interesting patterns on the base, so check before you throw them away!

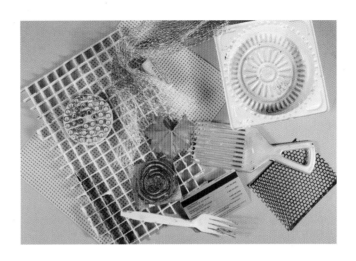

The end of a cardboard tube pressed repeatedly into light modeling paste

Plastic mesh pressed into heavy gel and removed quickly to create ridges

OPPOSITE: *Napa Treeline III*, Ann Baldwin, 18" x 24" (45.7 x 61 cm), acrylic, ink, modeling paste, crayon, heavy gel medium, photographs on canvas.

You can, of course, add paint to your gels and pastes, though it's hard to achieve strong darks when you mix with modeling paste.

Golden Clear Tar Gel is like liquid string. Using a stick or a palette knife, drizzle it lightly, Jackson Pollock style, onto your painting. It dries clear, so continue to paint over it with transparent glazes, or leave it alone. The tar gel can also be mixed with 25% fluid acrylic paint. This is an excellent medium for creating intriguing line work.

The side of a credit card pressed into modeling paste

Draw into modeling pastes and heavy gels with a wide-toothed comb, toothpicks, lollypop sticks, and plastic forks.

Two-Dimensional Optical Texture

Texture can be both tactile and optical. The tactile kind is associated with descriptions such as rough, smooth, bumpy, ridged, gritty, creased, crumpled, and silky. It responds to your sense of touch. Optical texture can be detected only by your sense of sight. Areas of a painting may appear to have three-dimensional texture, whereas really they are smooth to the touch. Imagine a photograph of a field of stubble. Experience tells us that the stubble is rough to the touch. But if you run your fingers over the photograph, it will feel smooth.

tip

Acrylic mediums are all adhesive, so lids easily become stuck. The first time you open the jar, rub Vaseline around the edge. Opening the jar will always be easy!

Push modeling paste through stencils for raised decorative elements. (See chapter 7 for instructions.)

Fine corrugated cardboard pressed into paint makes a grid pattern when printed both horizontally and vertically. The circles are printed with a cork.

Ways To Produce Two-Dimensional Texture

Many different media lend themselves to creating faux texture. Crayons and pastels provide depth by adding lines and dots in a patterned or random fashion. Light and dark colors can be mixed to create a three-dimensional effect. Recycled materials, such as bubble wrap, corks, or corrugated cardboard make good printmaking tools. Dabbing wet paint with paper towels gives the illusion of texture. Surfaces can even be scratched with a knife to add interest and create a weathered appearance.

Here are a few other suggestions:

- Dab a crumpled paper towel into a layer of thin wet acrylic. It will give an antique, mottled effect.

- Slice a cork in half lengthwise and use it to print small rectangles. Or use the end of a cork to print circles.

- Dip your brush in rubbing alcohol and allow it to drip into a wet wash of acrylic diluted with water. The alcohol dissolves the pigment forming interesting patterns.

- Press corrugated cardboard into a thin layer of dark paint on your palette. Print the lines onto your painting. Press down into the paint again, and then print lines at 90° for a mesh effect.

Repeated marks such as spatters or dry-brush strokes can give the illusion of real texture and add dimension to a painting.

Scribble over a plain background with crayons in different colors.

Add rock salt to a wet wash of diluted acrylic and leave to dry. The salt will soak up some of the pigment, leaving lighter spots when it is rubbed off.

Press bubble wrap into a layer of paint, and then print the "bubbles" onto another area of your painting. Take care not to overdo this effect or you'll end up with a "bubble wrap painting"!

When a layer of acrylic paint has just begun to dry, lay down some plastic cling wrap so that it forms creases. Leave in place until the paint is almost dry, and then peel off. The effect will be like crystals.

Lay pieces of cheesecloth and metallic ribbon onto a wash of acrylic ink. When almost dry (but not so dry that it sticks to the support), peel off the cheesecloth.

Creating a Textured Abstract Painting

In this demonstration, texture is the dominant feature, so you don't need a complex color scheme or a vast repertoire of shapes. The textures themselves are enough to give the piece some drama.

1 Apply a glaze of Alizarin Crimson. Dry thoroughly. With Paynes Gray on half a cork, print random rectangles. Scratch into another patch of Paynes Gray with a toothpick. Dry thoroughly. Glaze another area with Transparent Yellow Iron Oxide overlapping the blue.

2 Apply patches of light modeling paste with a palette knife. Imprint them with various patterns. Allow to dry thoroughly.

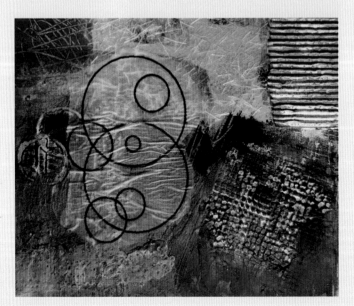

3 Paint over the modeling paste with glazes of Paynes Gray or Alizarin Crimson. With heavy gel medium collage some corrugated cardboard and a piece of doily.

4 Glaze over the cardboard and the doily. Add further areas of paint in a different shade of blue (Cerulean Blue Deep). With matte medium collage some rice paper. The final piece of collage contains circles printed on tracing paper. This creases dramatically when moistened.

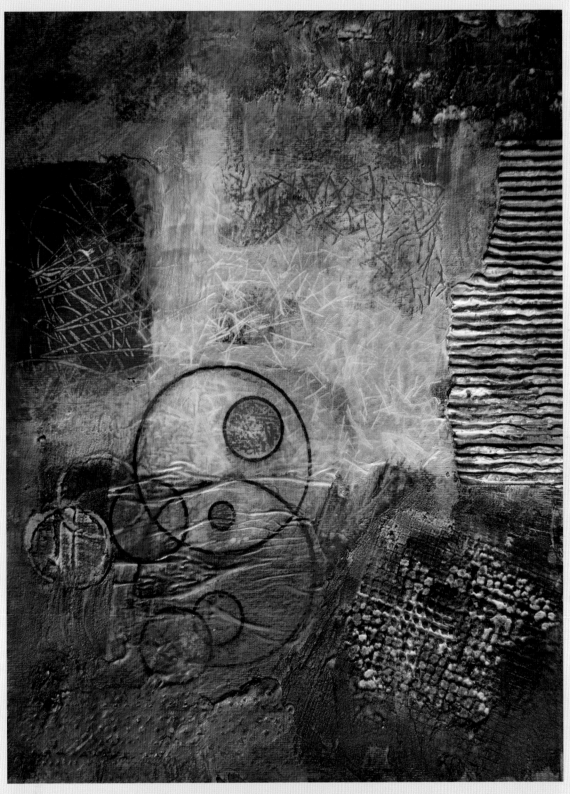

5 To finish the painting, embellish with crayon (Caran d'Ache wax-oil) rubbed over a section of the rice paper and drawn over the circles. Add a further glaze of Alizarin Crimson to some areas to give it a richer glow.

Layering Paint and Found Images

Collage "A technique of composing a work of art by pasting on a single surface various materials not normally associated with one another, as newspaper clippings, parts of photographs, theater tickets, and fragments of an envelope." (*Random House Unabridged Dictionary*)

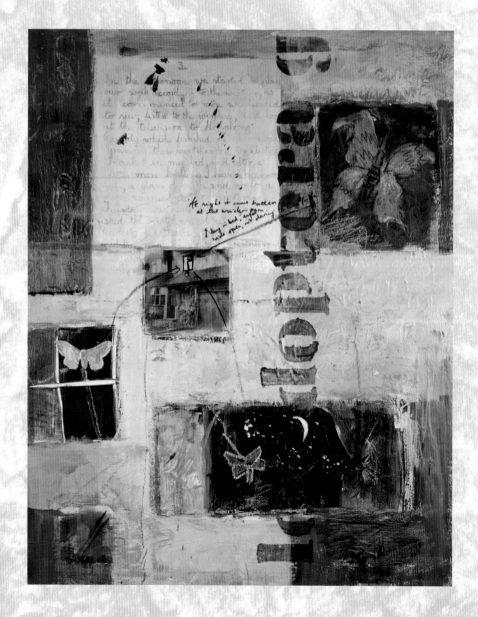

Flight of the Giant Moth, Ann Baldwin, 20" x 16" (50.8 x 40.6 cm), acrylic, crayon, collage on canvas.

In the early twentieth century, when Pablo Picasso was collaborating with Georges Braque, they invented the word collage, which derives from the French verb *coller* (to glue). Braque first purchased some wallpaper with a faux wood grain and used it in of his paintings. Picasso soon followed suit. But the art of gluing paper and other objects to a surface goes back much further. There is evidence that it all began with the invention of paper in China in 200 BC, although it wasn't until the tenth century that Japanese calligraphers turned it into a regular practice by gluing fragments of text to paper.

Proust in Love,
Ann Baldwin, 18" x 24"
(45.7 x 61 cm), acrylic,
collage, crayon, ink on
canvas.

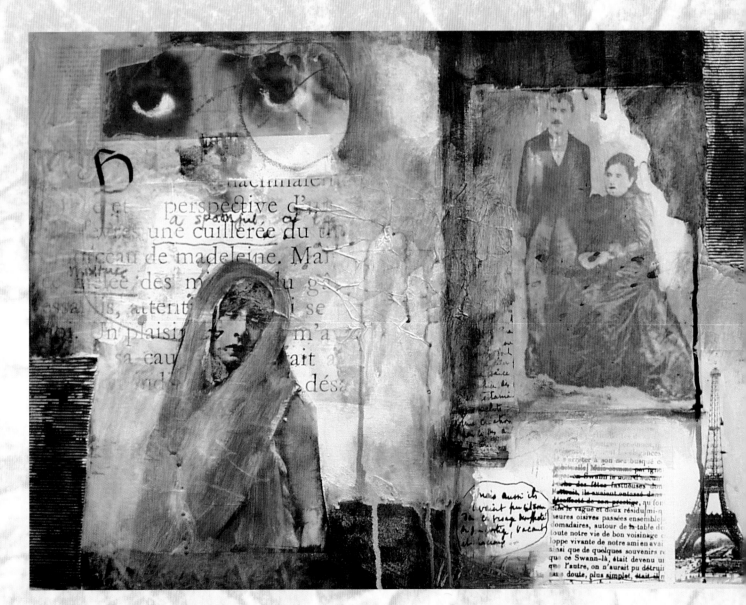

Selecting Images for Collages

Some dictionary synonyms for collage are: patchwork, random collection, hodgepodge, or clutter. Of these, only the first suggests any kind of planned design. The others are probably the very effect collage artists try to avoid!

How often have you declared in frustration, "This piece looks so disorganized, just a jumble"? Collage artists are usually pack rats. We have huge collections of old envelopes, postcards, used books, magazines, labels, tickets, and wrapping papers. What others regard as garbage, we see as rich pickings. "I never know when I'll need it," is a common remark. Artists arrive at workshops with suitcases full of found papers and prints, a thousand times more than they will need in one day—or, in some cases, in years!

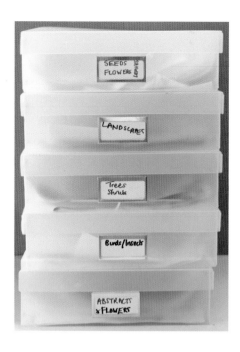

Translucent plastic boxes like these are lightweight and can easily be stacked on open shelves. Even a middle box can be carefully removed without taking all the others down. They are also readily portable for taking to workshops.

Matinées at Two,
Ann Baldwin, 22" x 28"
(55.9 x 71.1 cm), acrylic,
collage, crayon on canvas.

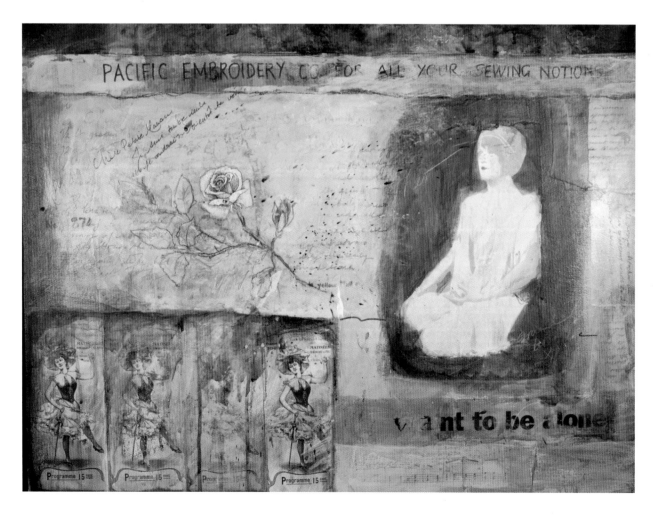

Being faced with so many choices can be overwhelming and even counterproductive. Over the years I have developed ways of organizing my collage elements according to themes. This means that, when I'm about to start a new collage, I don't have to dive into a huge box full of mixed images and text. I simply select a box labeled "Women's Underwear" or "Shakespeare's Theatre" or "Leaves and Seeds."

It is absolutely true that, barring copyright infringement, any found image can be used to make a collage. Rather than saving every magazine you can lay your hands on, consider your own particular interests. Make a list of subjects that are particularly attractive to you: birds, butterflies, cats, trees, old cars, soccer, dancing, music. From now on, when you're leafing through a magazine, tear out only those pages that focus on these subjects. (If you're afraid you'll decide on other subjects later, just keep a stack of these magazines somewhere. If you're feeling brave, toss them. There are plenty more where they came from!)

Now you're ready to fill your labeled theme boxes.

Starting a Mixed-Media Collage

To begin a piece of work, you should try to limit yourself to a dozen or so images from one particular box. One or two will be larger so that they can act as focal points; the rest will be medium or small.

Next, experiment with a variety of ways of laying these onto your support. Decide on which will probably be your "star" image, which will be merely background "scenery," and which will be your supporting actors. Sometimes you may decide on more than one main image. Remember, none of this is set in stone—remain flexible, bearing in mind that you will be using paint to alter and cover up some of your collage.

tip

Although you won't want to glue all your collage pieces before you add other media, having an idea of their overall arrangement can help you to get started. Without gluing, simply arrange the images on your support and take a digital photo. Use the print as a guide to composition as you work. The final arrangement may turn out differently, but this tool can give you confidence!

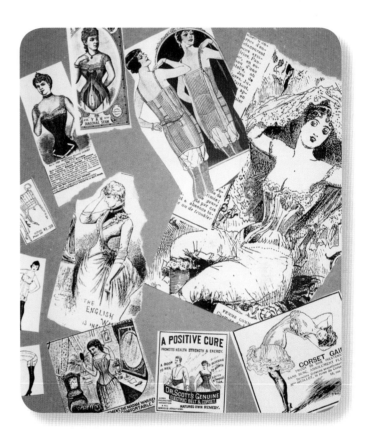

ABOVE: *There are probably too many images here for the final piece, but at least it's a manageable selection. You won't be spoiled for choice.*

LEFT: *Leave plenty of blank space to allow for areas that will be painted rather than collaged.*

Which Goes Down First: the Collage or the Paint?

A successful mixed-media collage is often a process of moving back and forth between paper and paint. If a blank support scares you, try painting it loosely all over with a thin layer of one of your favorite colors. Don't spend time making it perfect, or you might not want to cover it with collage.

Alternatively, you could begin by gluing on a background layer of less important imagery or small print. This will then be covered either with a layer of transparent color (a glaze) or translucent color—such as Zinc White or Titan Buff—to partially obscure it. Planning layers is a bit like planning moves in a game of chess or cards. Some of the early moves appear trivial, but if the player knows where she is going next, the moves add up to a careful strategy designed to achieve victory. In mixed-media painting it is best not to play your trump card too early. If you glue down your main image too soon, you will find yourself tiptoeing around it to avoid obscuring it. The best advice is: start with the small stuff, move on to the supporting images, and finally add your focal point. This approach allows you plenty of room for adding paint and other media as you go.

Of course, you may be the intuitive type, in which case go with the flow!

TIPS FOR GLAZING WITH ACRYLIC FLUIDS

- Before dipping your brush into the paint, be sure to wipe off excess water on a sponge or paper towel. This will help to eliminate bubbles or foaming.

- Mix some acrylic medium with the paint to increase transparency or reduce intensity of color.

- Paint with a nylon brush. It holds more fluid than a bristle brush, so the paint will go on more smoothly.

- Clean your brush thoroughly with water between glazes, making sure that you squeeze it out before applying the next glaze.

- Change your water often and keep separate pots for washing out light and dark colors.

- Allow each layer to dry completely before applying the next. It is often tempting to rush on to the next glaze.

- Occasionally glaze with a translucent paint, such as Titan Buff or Zinc White, allow to dry thoroughly, and then glaze over with a transparent color. The effect can be quite mysterious.

- Try glazing with a sponge: Pour a pool of paint onto the support, and use a slightly damp sponge to spread it evenly. Glazes can also be rubbed in with a strong paper towel.

- To achieve an antique texture, dab into a glaze with a paper towel or newspaper.

- Glazing fluid is slow-drying, so reserve the gloss for the final layer to create even greater transparency.

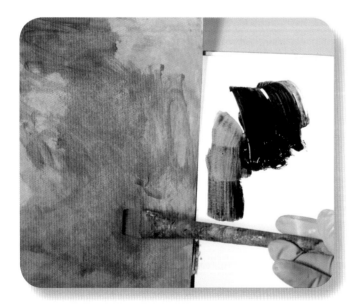

Jenkins Green fluid acrylic is being loosely painted over the whole support, providing a background for the first layer of collage.

Text in various sizes and orientations has been glued down as a background. This will later be partly or even mostly obscured.

Initial Layout to Final Image

Composing as you go can be difficult. Sometimes it helps to glue down all the major collage pieces from the start. A fixed design may work for you or you may find it inhibiting to have to protect these elements as you build new layers. A lot depends on whether you like to be in control or go with the flow.

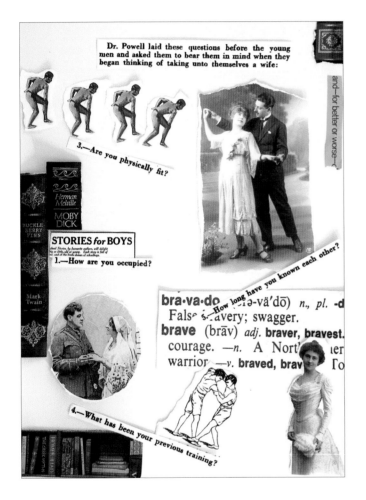

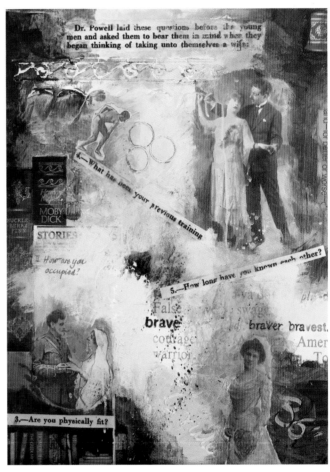

ABOVE RIGHT: *Marriage Questions*, Ann Baldwin, 24" x 18" (61 x 45.7 cm), acrylic, collage, ink, crayon on canvas.

Here the composition of the final painting is fairly faithful to the initial layout.

Layering with Glazes

The term glaze refers to a thin, transparent layer of paint. Glazes were popular with the old masters, who thinned down their oil paints until they were almost transparent in order to create subtle color through optical mixing—that is, the colors are not physically mixed by the artist, but are mixed in the eye of the viewer. A physical mix of blue plus yellow can result in a very different shade of green from one created by layering multiple glazes of alternate yellow and blue.

Here is a list of transparent colors that make excellent glazes. They can be mixed together to form dozens of other hues.

- Transparent Yellow Iron Oxide
- Transparent Red Iron Oxide
- Transparent Pyrrole Orange
- Hansa Yellow Medium
- Nickel Azo Yellow
- All the Phthalos
- All the Dioxazines
- All the Quinacridones

For a beautiful warm brown, try mixing Jenkins Green and Transparent Red Iron Oxide. For a vibrant black, mix Paynes Gray with Quinacridone Burnt Orange.

Although they are not officially transparent, Paynes Gray and Jenkins Green can be applied very thinly to make them appear so. In fact, all colors can be thinned with a fluid medium to increase their transparency.

Thin layers of Transparent Yellow Iron Oxide, Quinacridone Red, Ultramarine Blue, Jenkins Green, Quinacridone Crimson, and Transparent Red Iron Oxide have been laid down over waterproof ink marks. Each layer must be dried thoroughly before the next is applied, or the colors will mix physically. The paint would still be transparent, but the colors would be changed.

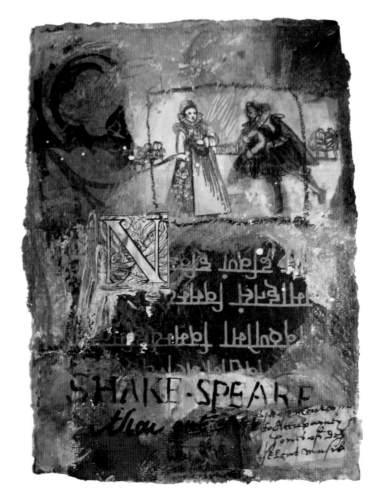

The Proposal, Ann Baldwin, 8" x 5" (20.3 x 12.7 cm), acrylic, found images on paper. Private collection.

Even a very small painting like this can be made into something special with transparent glazes of fluid acrylic paint.

Help, I Covered My Image!

One of the most frequent cries of woe from any collage artist is, "I just covered up something important—what do I do to get it back?" If the acrylic paint is still wet and you painted a layer of clear medium over your image before you painted over it, you might be able to wipe off enough paint to restore its visibility. But if the paint is dry and it's not transparent, there's only one answer: glue on another image. Consider making several copies of your most important images before you begin, so that you always have a duplicate with which to start afresh. The other solution—and one I use often—is to be flexible and select an alternative image. The result will be different, but it could be just as good. Only you know what you had in mind. Only you know the history of your painting!

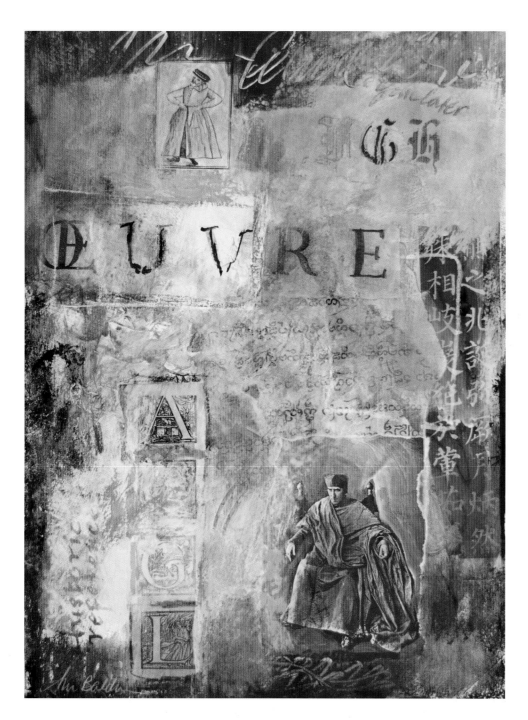

The Cardinal, Ann Baldwin, 15" x 11" (38.1 x 27.9 cm), acrylic, collage, crayon on paper.

You'll never guess what used to be where the cardinal is now, but it was something quite different!

Disguising Edges

In order to integrate collage into your painting, you will often need to make the edges of the torn or cut paper "disappear." There are a number of ways to do this.

tip

If you can't disguise an edge, emphasize it! You can do this by outlining it with oil pastel or crayon. Or paint a shadow alongside two edges to give it a 3-D effect.

The thicker the piece of collage, the thicker the paint or medium must be to fill in the edge. With a palette knife, spread a layer of heavy gel medium just over the edges of the collage until they are buried, and then smooth it out. The medium will dry clear.

When it is dry, paint a glaze of transparent paint to match the background, making sure it extends over both sides of the edge.

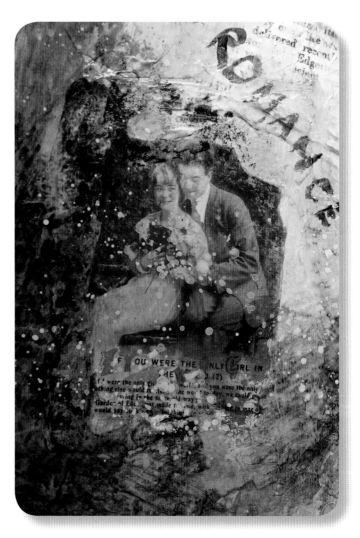

A dark-hued paint has been used to match the dark background of the original image. It has been extended beyond the edges in order to make them less obvious. Spattering has further taken attention away from the edge texture. Be sure to analyze the colors and textures of your surrounding area before choosing your method for making the division seamless.

Brainstorming Ideas in Writing

Remember those wonderful illustrated books you read as a child? The pictures brought the characters and situations to life. Mixing words with images can do the same in your collages. A ready source of stories is your own life. How about making rapid notes on some of these:

- A special family gathering—birthday, anniversary, memorial, July 4th, Thanksgiving. Don't try to recount the whole thing, just a few snippets—Did something funny happen? An incident with the food? Odd behavior by a relative? Bad weather? Who was there?A game you used to play as a child

- A special trip—vacation, camping, hike, bike ride, bus trip, train ride

- Your favorite recipe—or your mother's, aunt's, and so on

- Your pets—now or then. Did they eat your homework or the family dinner? Break something? Escape?

- A special outfit you remember. (Describe or even draw it, no matter how simply.)

- Moving home

- Getting married or divorced

You can be humorous or serious, or a mixture of both.Little illustrations all add to the personal nature of your collage. If you can't find suitable family photos, use found images of people as stand-ins.

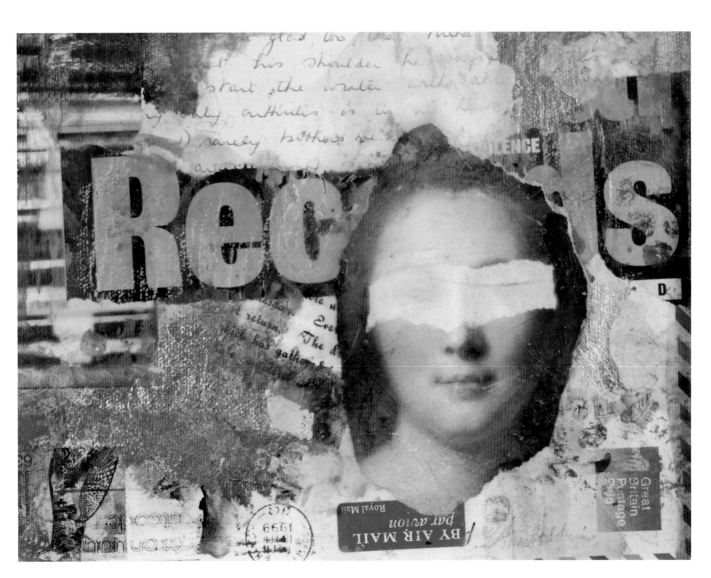

Anonymous Letters,
Ann Baldwin, 8" x 10" (20.3
x 25.4 cm), collage, acrylic,
crayon on canvas.

Working in Series

One advantage of organizing your collage into themes is that you can be inspired to create several paintings on the same theme. Here are some pieces from a series on women and their often confusing roles—glamorous, domesticated, and romantic.

A series can be just three or four pieces or a lifetime's work. For three years I concentrated almost entirely on Shakespeare's plays and characters. Later I turned to Marcel Proust.

Diary of a Chorus Girl, Ann Baldwin, 11" x 14" (27.9 x 35.6 cm), acrylic, found imagery and text on paper.

Here the text comes from an antique magazine I bought online.

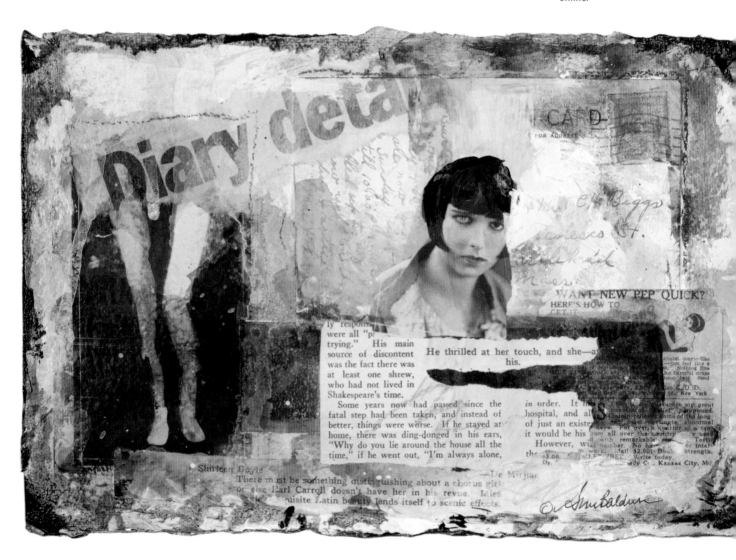

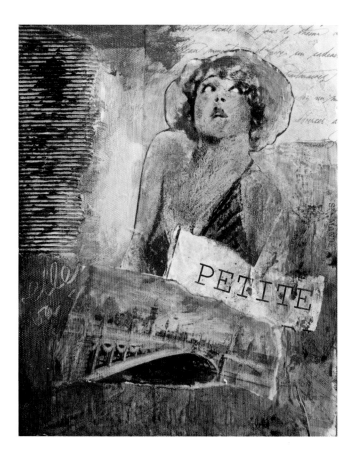

LEFT: *Petite Blonde*, Ann Baldwin, 10" x 8" (25.4 x 20.3 cm), acrylic, collage on canvas. Private collection.

The text was enlarged from a newspaper ad for a dating agency.

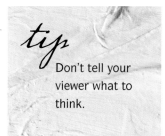

tip

Don't tell your viewer what to think.

LEFT: *Louella's First Flight*, Ann Baldwin, 16" x 20" (40.6 x 50.8 cm), collage, acrylic, oil pastel, crayon on canvas. Private collection.

Paintings can entertain as well as provoke. The idea that this woman is exercising in order to be ready to fly is, of course, ludicrous.

A Step-by-Step Painting with Found Imagery

This painting was commissioned by some good friends. The subject matter was suggested rather than prescribed. It can be difficult producing a piece of art specifically designed for others, but in this case the subject, Shakespeare, is one of my great interests.

Materials

- pre-gessoed canvas
- selection of photocopied found images
- large Sharpie
- Golden Fluid Acrylics: Transparent Yellow Iron Oxide, Quinacridone Crimson, Paynes Gray, Titan Buff

- Golden Heavy Body Acrylics: Naples Yellow, Yellow Oxide
- Golden Matte Medium
- Golden Heavy Gel Medium for texture

- rubber shaper
- 1" (2.5 cm) flat nylon brush
- 1" (2.5 cm) bristle brush

1 A 48" x 24" (121.9 x 61 cm) pre-gessoed canvas has been used for this painting. Random marks and sentences are written with a large Sharpie. Pieces of relevant photocopied text, music, and a diagram are then glued on with matte medium.

2 Some collaged items have been partially covered with a loose layer of fluid Titan Buff. When this is dry, more collage is added, including two pieces of striped wallpaper. Glazes of Transparent Yellow Iron Oxide loosely cover quite large areas. Heavy-bodied Yellow Oxide, Naples Yellow, and Titan Buff are then painted onto some of the collage to make it less visible. Notice that the paint appears quite random at this stage.

3 Quinacridone Crimson has been added with visible brushstrokes. This provides a tonal contrast to the paler yellow and Titan Buff. In places, rectangles of color begin to give the painting structure. The large, brownish rectangle has been written into with a rubber shaper while the paint was still wet, revealing the layer below.

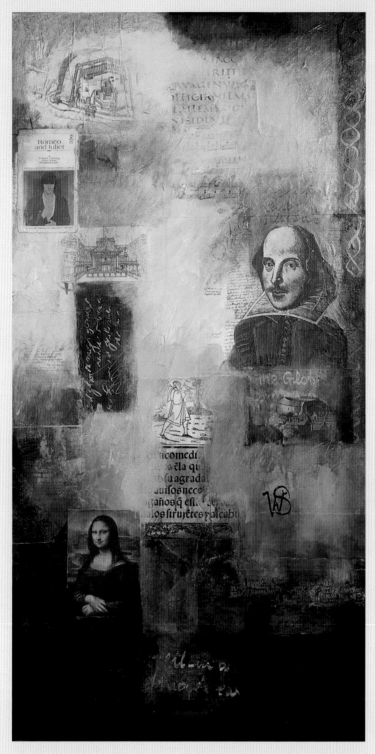

Humanities, Ann Baldwin,
48" x 24" (121.9 x 61 cm),
mixed media on canvas.
Collection of Nancy and
Robert Berke.

4 At this stage the final pieces of collage have been added: the image of Mona Lisa, the front cover of a paperback version of Romeo and Juliet, two more images of the Globe Theatre, and the image of Shakespeare himself as a focal point. More glazes of Titan Buff have been used to "push back" the collage, and further glazes of Transparent Yellow Iron Oxide and Quinacridone Crimson ensure that these final elements are integrated with the rest of the painting. Note that by now most of the early Sharpie marks have disappeared. As a final touch, a pattern has been scraped into the paint down the right-hand side and the initials WS (for William Shakespeare), which were covered up, have been revived.

Combining Words and Paint

Words can add mystery or meaning to a painting. They can provide a narrative, leading the reader or viewer to a certain interpretation of other elements in the painting, whether these are images or mere shapes and colors. Or they may be shrouded in veils of paint, masked in tissue paper, leaving the viewer to guess at what lies beneath. Some words in close proximity read like poetry: lonely, falling water, sad sound. Others may be more mundane: fish, chips, chair, rest. The painted word can be bold, ostentatious, elegant, faint, reassuring, exciting, and many other things.

A handwritten character over some medieval printed text makes a bold statement but does not require a lot of skill. Anyone can draw a capital C and embellish it with the odd curl.

Words are made up of curved and straight lines. For example, the word ART written in printed capitals has three diagonal lines, one curved line, three horizontal lines, and two vertical lines. Line is an important element of composition, whether it comes from writing or drawing. Like lines, words can provide a pathway from one part of a painting to another. Horizontal and vertical lines of print can give structure. Even a barely legible, scrawled phrase can animate a plain area, encouraging a viewer to examine it more closely. You don't have to be a calligrapher to make words look interesting. It only takes a little bravado to add a few freeform flourishes and swirls to numbers or letters!

The printed word is often more precise in appearance, more organized. Look for variety in found text. Handwritten characters, on the other hand, can be free-flowing and may be quite decorative.

Changing Styles

Remember when you were a teenager and you used to practice your signature in a dozen different styles? Chances are you were trying to find a way to express your personality. A particular font or style of writing can suggest a certain mood or character: Serious, frivolous, comic, scary, crazy, formal, romantic.

Word Labels

A word or two can complement your pictures and add content to the "story" you are creating. The interpretation of a photo of a small boy standing beside a dog can be altered by the addition of a particular phrase like "time for a walk" or "best of friends." However, it can sometimes be more intriguing to use words that leave something up to the imagination. How about "waiting" and "wishing"? With less obvious labels like these, everyone will dream up slightly different meanings, depending on their own experiences.

The word "bravado" copied and enlarged from a dictionary adds poignancy to the image, perhaps suggesting that the newly married couple will soon have to part as he goes off to war.

LETTERS AS ABSTRACT SHAPES

Learn to see letters and numbers in the abstract. You already know that an O is a circle or an oval, and an X is a cross, but do you think of a Y as a fork, or a Z as a zigzag? Choose an unfamiliar alphabet (found text, or hand copied). Scour the library or used bookstores for foreign texts, but take care that the subject matter is appropriate! A manual on shorthand contains fascinating symbols. Or run a search for ancient letters and numbers on the Internet. Consider the symbols used in astrology or mathematics.

- Turn words upside down or sideways.
- Stencil letters on the diagonal.
- Create a mirrored image.
- Superimpose one word over another.
- Cut words in half horizontally.
- Invent your own letters.
- Make up words—Shakespeare did!

The lines of Cs across the top here have a decorative effect. Foreign words or words that are incomplete and partially obscured carry mystery.

Handwriting

You can write with any drawing instruments: pencils, crayons, charcoal, oil pastels, ballpoint pens, felt pens, bamboo pens, and pens with interchangeable nibs.

You can also write with paint, using brushes of varying shapes and sizes: bamboos, riggers, liners, scripts, flats, filberts, rounds, cat's tongues, and daggers. Each will produce a different style. For example, a flat brush works well for blocky characters; a liner can create long, sweeping curves; a dagger is perfect for the broad and fine strokes in italic writing. Soft brushes made of nylon or natural hair are better than bristle brushes, as they hold more paint. Fluid acrylics or acrylic inks flow freely, whereas heavier paint will clog the brush.

Crayons, colored pencils, pastels, pens, and paintbrushes make different kinds of marks.

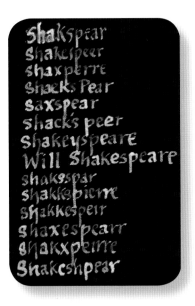

LEFT: *Writing with a broad-nib pen and white acrylic ink on a black background results in a striking mixture of boldness and transparency.*

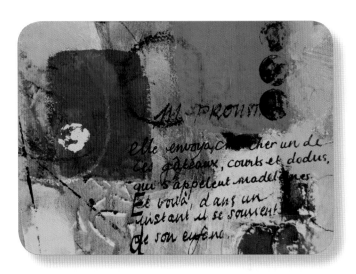

A busy abstract expressionist pattern is pushed into the background by superimposing handwritten text.

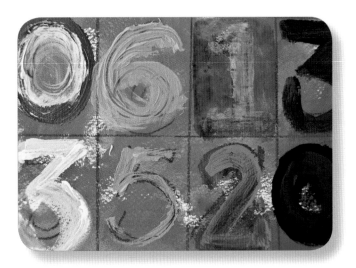

Numbers roughly painted in a grid, each one slightly different in style or color, have a painterly appearance. Jasper Johns adopted this approach in some of his early work.

tip

Always test that the ink in your pens and the pigment in your pencils or crayons is thoroughly waterproof before writing with them on your painting. Scribble on a separate sheet of paper and rub with a moist brush to test them. It will save some nasty surprises when it matters most!

Writing into Acrylic Glazes with Rubber Shapers

Rubber shapers also make excellent writing implements, pushing away wet paint from one layer to reveal the painted layer below. Their tips come in a variety of shapes and sizes.

Materials

- matte medium
- soft nylon brush
- fluid acrylics (one dark and one light)
- rubber shaper

1 Cover your support with a clear layer of matte medium. This seals the surface and helps the shaper to glide over it more easily.

2 Apply a layer of fluid acrylic in a darkish color (such as Paynes Gray). Allow to dry thoroughly.

3 Apply a layer of a light color (such as Titan Buff or Titanium White). While the paint is still wet, write into it with a rubber shaper. The tip will push away the wet paint to reveal the layer below.

You could instead reverse the colors, starting with a light color and covering with a dark one. Or try a multicolored bottom layer for a less predictable result.

tip

Avoid adding water to your acrylic paint when writing with rubber shapers. Water reduces the viscosity of the paint, so it tends to run back into the letters as you create them.

Stenciling

Letter stencils are available in many different styles. You can buy them in home improvement stores, and in office or art supply stores. Many more in unusual fonts are available online. Turn them back-to-front for mirror images. Always use a stencil brush, which is short and stubby with stiff bristles, making it easier to push the paint into the letter spaces. Heavy-bodied paint works best as it will not creep under the stencil. It also helps to spray the back of the stencil with repositionable adhesive to hold it firmly in place while you work.

Stenciled letters in fancy fonts almost look handwritten.

Texture mediums, like Golden Light Molding Paste or Extra Heavy Gel Medium, can be applied with a palette knife through stencils to create a three-dimensional effect. Once the raised letters have dried, they can be painted with transparent glazes. Bear in mind that it is difficult to collage over heavy textures, so it's probably best to save these bas-relief effects for the topmost layer.

With a soft brush, apply a thin layer of fluid acrylic paint. Allow to dry.

Load a flat bristle brush with heavy-bodied acrylic in a darker color. With the brush on its side, gently touch the surface of the raised letters.

Provided the paint is not too wet, the letters will appear roughly painted to emphasize texture. Allow to dry.

Using a different color, add another thin glaze of fluid transparent acrylic over part of the area. In fact, you can add several more glazes, but be sure to let each layer dry before you apply the next.

Photocopy a messy stencil against a white sheet of paper. The white letters outlined with splashes of paint can look spectacular.

Hand Printing

Rubber stamps are an obvious choice for printmaking. But cut foam or cardboard, and even potatoes, make good prints too.

- Print with transparent paint over opaque.

- Use light paint over dark or dark over light.

- Blurring—intentional or not—can be exciting.

- Apply very little paint, so that large areas of the letters are skipped.

And remember—neatness isn't necessarily a virtue! Aim for that handmade look.

These old wooden letters were found in an antique toy store. They can be pressed into wet paint and used as stamps.

Simply draw the letter (roughly or neatly) onto the surface of the material and cut around it. In the case of absorbent cardboard, it can be helpful to glue the character to a thicker cardboard base, and then apply a layer of matte medium to seal the surface. Ink or paint applied to the surface will be more easily transferred to the painting surface.

Try repeated printing of a letter in almost the same spot, but slightly offset.

Make Your Own Letter Block

Rather than purchasing ready-made printing blocks, you can make your own with pre-cut stencils. These come in many different designs with both letters and images. Find them in your local home improvement or craft store. Plastic stencil blanks are also available for cutting your own design from traced or hand-drawn images.

Materials

- sheet of stiff cardboard
- letter stencil
- brayer
- Golden Light Molding Paste
- palette knife
- old credit card
- clear acrylic matte spray
- thick acrylic paint

1 With a letter stencil sheet positioned over a stiff sheet of cardboard, push through Golden Light Molding Paste with a palette knife. Since you'll need the letters to end up all the same height, be sure to level off and remove any excess paste.

2 While the paste is still wet, peel off the stencil carefully to keep the letters intact. Allow to air-dry thoroughly. Spray on a couple of thin layers of clear matte acrylic.

3 Spread a layer of heavy-bodied acrylic paint over a sheet of palette paper. Transfer paint to the brayer by rolling it back and forth over the paint.

4 Ink up the letter block by rolling the brayer over the raised area.

5 Print! The block will not need to be cleaned off after use, as the acrylic paint will dry waterproof. But remember to wash off the brayer thoroughly to preserve its smooth surface!

Create and Destroy!

Have you ever stopped to stare in admiration at some amazingly colorful, virtuoso graffiti painted over billboards or posters? Legal or not, what you are looking at is a mixed-media painting. Usually the artists or "taggers" have their own unique styles, which may be quite ornate or cartoonlike. Frequently the poster underneath is weathered and torn, adding a further dimension. Try "defacing" your own found text in this manner. You can stick the image onto a firm surface—a canvas board or wooden panel—then, when it has dried, scrape parts of it away with a knife, or rub it with sandpaper until only parts of words are left. Finally, add graffiti!

True Confessions

You don't have to be a novelist to write stories; visual artists can do it too. Many artists already enjoy journaling, which is a form of autobiography. Write in note form if you don't want to take time over long accounts: "Pizza with Paul. Rude waiter, but great wine. Saw Lela and Rudi cozy together in a booth." Consider scribbling rather than writing neatly to give your art a more spontaneous atmosphere. Illustrate with drawings, which can be childlike or sophisticated, depending on your level of draftsmanship! Confessions don't have to be true, either. Adopt another persona; invent her thoughts.

The Second Reader (detail)
Four pages of an old reading primer have been scrawled and scribbled onto with crayons, then gouged into with scissors to tear away parts of the collage. Mottled glazes of transparent paint add to the weathered look.

said he, "and I will decide
... your quarrel."
... and gave one half
... saying, "This is for you,
you saw ... fall."
... gave ... half sha.. to the
boy, saying, "... is yours, because you
... up the nut."
... putting ... kernel into his own
... he said, "And this is mine for my trouble
king it."

LESSON LX.

clothing ... cooper ... thinks
... ing ... falling ... vains
white'ness hap'py
... asking for ... Bride, a woman newly
... married.
... rays of the west, thirst y, craving drink.

LITTLE WHITE LILY.

I. LITTLE white lily
 Sat by a stone,
Drooping and waiting
 Till the sun shone.

I have seen boys throw stones at cows. I
... not think they would do it if they thought
... how useful the cow is. I ... seen
... drive them fast. That, too, is ... cruel,
... spoils their nice milk.

Let us be kind to cows and ..., and
... which are so useful to us; then they will
... and follow ... and that is much better
... making them run away from us in fear.

... SON LVII.

... ock
... let ... dip
... bling ... with a
gentle nois...
... COW.
THANK you ... co...

7. *Arthur.* O, George, do not tell John! I will
go and tell him myself, and give him back his
money.

8. *George.* Very well; then I will say nothing
about it. But I hope you will not forget in
future what our master told us. "A *good bargain*
is one from which both the buyer and seller
derive profit;" and not, as you seem to have
thought, that in which one is a cheat, and the
other is cheated.

LESSON LXI.

pail	caught	tea'spoon	tum'bling
re-plied, *answered.*		ea'ger-ly, *earnestly.*	
in-quired, *asked.*		hur'ry, *haste.*	

CLOUDS, RAIN, AND SNOW.

1. ONE morning, Willie's mother called ...
and said, "I told you, my dear, that I ...
show you when a cloud was falling. L...
of the window, and you will see one ne...

2. Willie ran to the window in a ...
to see what he thought must be ...
eight. He looked first up to the sky; ...
looked to the right, and then ... no-
where could he see anything ...

NAMING THE KITTENS.

1. HERE are a boy and a girl, who are looking

Pulling it All Together

How can you incorporate several of these techniques successfully into one painting without it looking chaotic? The answer is: Layering. By placing some collage items on the lower layers and some on the upper layers, you have more flexibility with regard to composition. Think of your lower layer as background texture. You don't want too much detail to show up in the final piece or it will look overcrowded. Paints like Titan Buff and Zinc White are translucent: They allow some details to show through, while veiling others. Transparent pigments act like colored glass: Everything can be seen through them, as through sheets of colored cellophane. They add richness and depth to the painting. Writing or stamping directly onto a layer also allows other layers to remain visible.

Materials

- sheet of 140 lb. (64 kg) watercolor paper
- matte medium
- printed text in a variety of styles and sizes
- letter stencils
- tube of Golden Paynes Gray acrylic paint
- stencil brush
- Golden Fluid Acrylics: Titan Buff, Paynes Gray, Transparent Red Iron Oxide, Transparent Yellow Iron Oxide
- ¾" (1.9 cm) flat nylon brush
- fine Sharpie in brown or black
- rubber stamp of a single character

1 Cover the entire support with a layer of acrylic matte medium to seal it. Adhere a few pieces of printed text, and then cover these with matte medium too. Allow to dry.

2 Add stenciled letters with Paynes Gray fairly randomly over the text, using the stencil bush. Allow the paint to dry. Clean the brush very thoroughly immediately after use, otherwise paint will harden in the metal ferrule and you'll end up with a stubby stick!

3 Cover the support with a loosely applied layer of Titan Buff to partially obscure the letters. Allow to dry.

4 Apply another loosely painted glaze of Transparent Red Iron Oxide. Allow to dry.

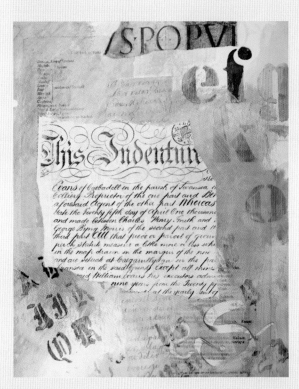

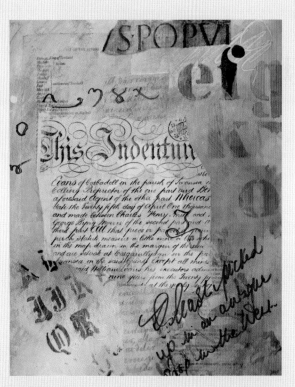

5 Add a couple more pieces of collage in the form of handwritten text or found words. Use matte medium to adhere and to seal afterward.

6 Add a glaze of Transparent Yellow Iron Oxide over part of the painting. Allow to dry. Write directly onto the painting with a fine Sharpie.

Pulling it All Together (continued from page 93)

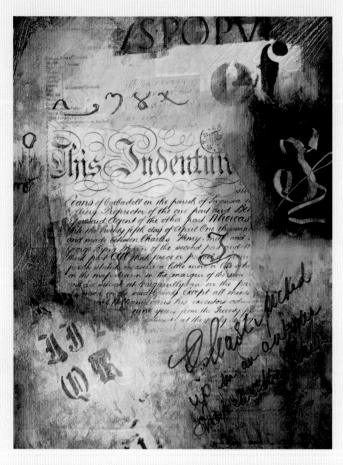

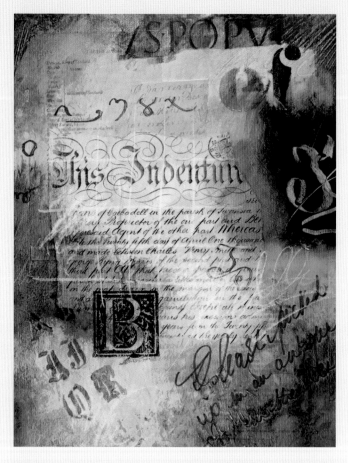

7 Darken some areas of the painting with a glaze of Paynes Gray fluid acrylic. Paint a small area with Paynes Gray tube acrylic, then write into it with a broad-tipped rubber shaper to reveal the lighter glaze below.

8 Use a rubber stamp painted with Paynes Gray tube acrylic to add the final touch. Be sure to scrub the paint out of the stamp with a stiff nailbrush immediately!

Indenture,
Ann Baldwin, 15" x 11"
(38.1 x 27.9 cm), mixed
media on paper.

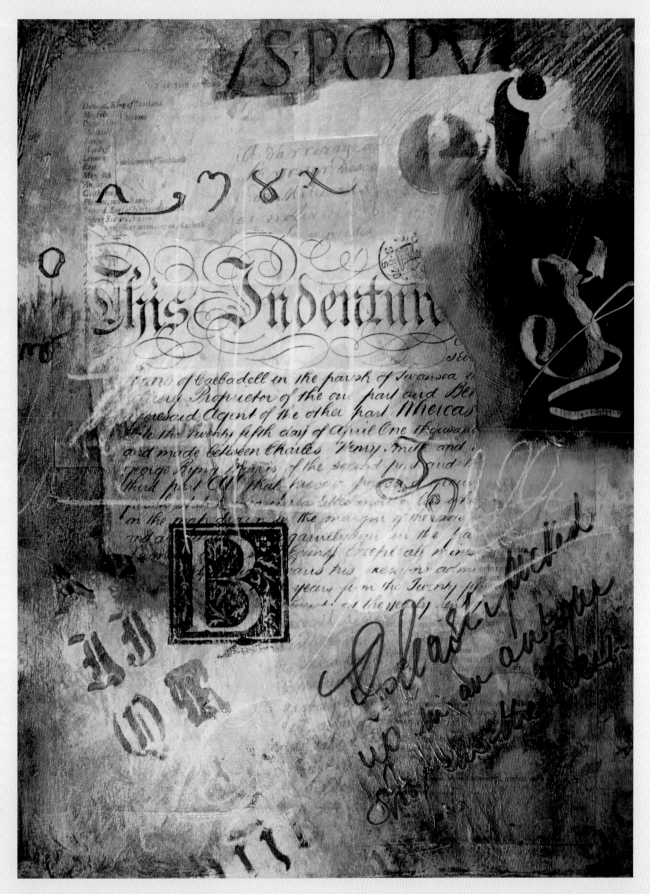

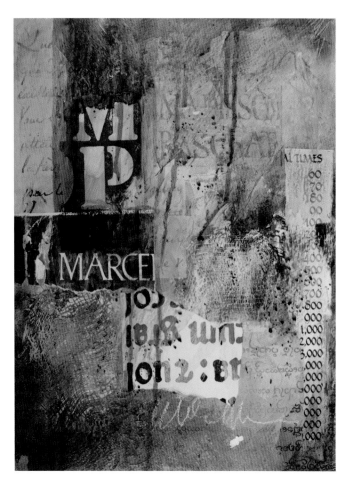

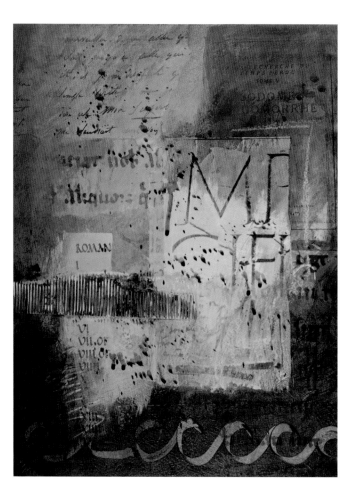

Remembering Proust, Ann
Baldwin, 15" x 11" (38.1
x 27.9 cm), collage, ink,
acrylic.

Inscription #6,
Ann Baldwin, 15" x 11"
(38.1 x 27.9 cm), collage,
ink, acrylic, oil pastel.

Addition, Ann Baldwin,
15" x 11" (38.1 x 27.9
cm), collage, ink, acrylic,
oil pastel.

Chapter 7

Working with Encaustic Materials

So far our painting medium of choice has been acrylic. Painting with wax is an entirely different experience, but if you love texture, encaustic paints could really inspire you. In my experience, encaustic paintings seem to paint themselves. The unpredictable way in which wax responds to heat makes the process of moving it around on the support both a gamble and a thrill. Accidental effects (I won't call them mistakes) are a regular occurrence when you are new to the technique.

Subtext III, Ann Baldwin, 8" x 5½" (20.3 x 14 cm), encaustic collage on cigar box.

What Is Encaustic Painting?

Encaustic painting is a technique of heating a mixture of beeswax and dammar resin, and applying it to a hard, porous surface, such as wood or ceramic. Paper and card can also be used as supports. To create paint, powdered pigments or a small amount of oil paint can be added to the beeswax medium. Some companies, like R&F Encaustics in the United States, sell encaustic paint in the convenient form of small blocks.

Encaustic is an ancient artistic form dating back more than 2,000 years to the Egyptian Fayum mummy portraits, which were painted on wooden boards and attached to the faces of burial mummies. The fact that these were not unearthed until the late nineteenth century is testament to the durability of the medium. Jasper Johns is probably the most famous modern practitioner of the art of encaustic painting, which has been enjoying a revival since the 1990s.

Once you start experimenting with painting in hot wax, you can easily become completely hooked. The smell is delicious, the textures are sensual, and the colors are earthy. You can create paintings that look like old tablets or walls on which words have been scratched, erased, pasted, and overwritten. You can build layer upon layer, sometimes etching and scraping to reveal the layer below. You can encapsulate copies of old documents and images from antique magazines in clear wax medium.

ABOVE: *Manuscript*, Ann Baldwin, 11" x 5" (27.9 x 12.7 cm), encaustic collage on cigar box.

LEFT: *Annotations* (detail), Ann Baldwin, encaustic, oil stick on hollow-core door.

Equipment

An encaustic workspace can look more like a kitchen than a studio. You will need a hotplate or griddle on which to melt the wax pigments, a Crock-Pot or electric fryer for the medium, and an iron to fuse one layer of wax with the one below. Heat guns, which can be purchased in hardware stores, also aid in directing heat onto particular areas of a painting. Each of these should have a built-in thermometer that can be set to 200°F (93°C). Anything hotter than this will cause the wax to smoke. Hair dryers and heaters designed for embossing with rubber stamps won't work, as they're not hot enough.

Other materials, such as shells, nails, and paper collage, can be embedded into the hot wax. Never try using anything made of plastic, as it will melt and could even cause a fire.

Although melting wax is not toxic, the fumes can be irritating. If your eyes start to itch or your throat gets scratchy, then you can be sure you need more ventilation in your work space. Ideally you want a way to extract the fumes. For this you will need an extractor hood or a fan set into a window. If your room has windows that open on either side of your table, make sure that the wind is directing the fumes away from you. Keep a small fire extinguisher close by in case of an accident.

You should only purchase encaustic paints and beeswax medium from reputable art suppliers. Candle wax and wax crayons won't work well. The best way to begin is to attend a short workshop where the materials are available for you to try out. Although it's tempting to buy a whole array of colors, good encaustic paints are quite pricey. Remember, colors can be mixed! They can also be "extended" by adding a higher percentage of medium. Small amounts of oil paint or oil stick added to the medium will produce subtle transparent colors.

A nonstick electric griddle and fry pan, each with a thermostat

Clockwise from top left: heat gun with built-in fan, fan nozzle, travel iron, small blowtorch designed for crème brûlée

Metal palette knives and bristle brushes can be used to manipulate the wax before it has cooled. After it hardens, a variety of metal or wooden implements, such as dental or metal palette knives, can be heated and used to smooth the wax. Cheap bristle brushes get clogged with wax but can easily be left to warm and soften on the griddle before reuse. Razor blades are used to scrape and smooth still-warm wax. Various wooden, metal, and ceramic tools are for etching and scratching into the hardened surface.

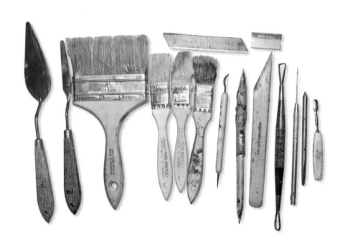

You can buy beeswax in bulk too. If you do this, make sure that you buy filtered and refined beeswax, not bleached (which will lighten your colors) or unfiltered (which is yellow and will change your colors).

Drawings and marks can be made on cold wax with oil sticks, just as you would with crayons on acrylic paint. Oil sticks should contain very little filler; otherwise the particles will break up and float away when the wax is reheated.

Paraffin wax, available in powdered form, is best for cleaning up your hot plate. Just melt a little on your hot plate and wipe away the paint.

Encaustic paints come in bars or cakes for melting on a hot plate. Oil sticks are used like crayons and can be rubbed into the hardened, textured wax surface.

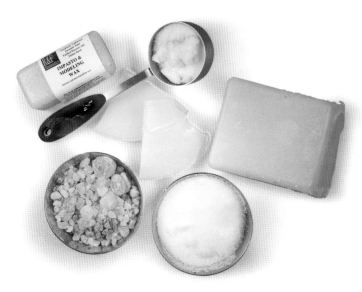

Companies like R&F offer premixed mediums in cake form. You can also make your own from powdered beeswax and dammar crystals. Powdered paraffin wax is used for cleanup.

MAKING YOUR OWN WAX MEDIUM

To save money you can make your own medium with beeswax and dammar crystals.

Recipe for Encaustic Medium

You will need:
- 4 oz (113 g) dammar crystals
- 1 lb. 2 oz (510 g) beeswax (Buy the powdered kind.)

Method:

1. Put dammar crystals in a double plastic bag and batter with a mallet until they form a coarse powder. Put through a sieve to filter out any extraneous plant matter.

2. Melt the beeswax in a clean skillet (not cast iron, as this will alter the color of the mixture).

3. When the beeswax is thoroughly melted, add the dammar crystals at 250°F (121°C) for approximately 30 minutes, or until the entire mixture is molten. Do not overheat. It's best to use an electric pan with a thermostat. Stir regularly to ensure that the mixture does not stick to the bottom of the pan.

4. Lower the heat to 225°F (107°C). Continue to heat the mixture for another hour, stirring occasionally.

5. Ladle the mixture carefully into a saucepan, leaving larger bits of debris (bark, elephant hair, bugs, etc., from the dammar resin) in the bottom of the skillet. Wipe these away with a paper towel. Then pour the mixture through a strainer or a fine metal sieve back into the skillet.

6. Finally, ladle the medium into pre-oiled muffin tins and allow it to set. You can cool them in the refrigerator and pop the cakes of medium out of the molds when they are very hard.

Warning: Never use these utensils again for cooking, even if they do look clean.

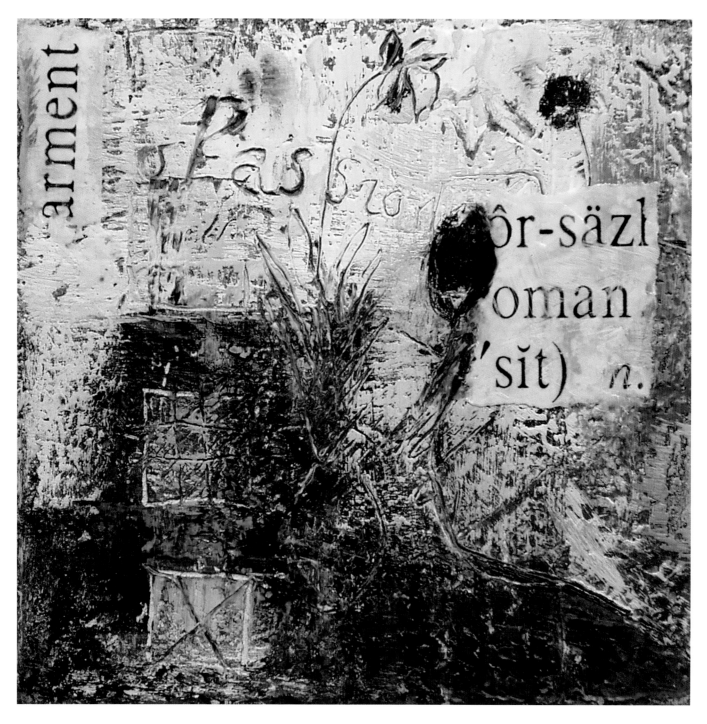

Passionflower, Ann Baldwin, 10" x 10" (25.4 x 25.4 cm), oil pastel, collage, encaustic on board.

Here the medium itself— hot wax—is applied very thickly and unevenly. Since it hardens so fast as it cools, the surface texture remains prominent.

Frequently Asked Questions

DOES ENCAUSTIC PAINT MIX WITH OTHER MEDIA?

Yes, you can mix it with oils, but bear in mind that wax dries faster than oil paint. If you apply a layer of wax over a layer of oil paint that hasn't yet cured (this can take up to a year, depending how much oil is in the paint), the wax will eventually crack. It's best to mix just a smidgen of oil paint with the encaustic to change the color. You can also etch into the cold wax surface, and then smear oil stick into the lines, wiping off any excess with vegetable oil and a soft cloth. R&F Paints sells suitable oil sticks and will also send you a chart of drying times for the various colors. Black, for example, takes much longer to dry than Umber Greenish, which looks like black. After you have applied the oil stick, you should paint over it with some clear wax medium then fuse the layers with a heat gun or iron.

WAX AND PLASTIC DON'T MIX!

Wax and acrylic paint are totally incompatible! This is because acrylic is a plastic polymer that remains flexible and nonabsorbent. Therefore, it will not fuse with the wax . . . ever. A layer of clear beeswax over an acrylic collage will eventually drop off. The secret to successful encaustic painting is in the fusing. Every single new layer of wax must be gently melted with a heat gun or an iron to join it to the layer underneath.

Cigar boxes, Masonite, clayboard panels, birch plywood, and paper all make good supports for encaustic paintings.

WHAT IS THE BEST TYPE OF SUPPORT FOR ENCAUSTIC PAINTINGS?

In Europe a lot of hobby painters use special card. This is less popular in the United States. By far the most archival support is wood, because it is inflexible and highly absorbent. Again, you are taking measures to ensure that the paint remains firmly in place.

Paper is flexible. When it bends, the wax can pop off. Mat board or 300 lb. (136 kg) paper is rigid enough.

Canvas, due to its extreme flexibility, is unsuitable unless you mix a lot of oil paint with your hot wax. (Some oil painters use a medium that contains cold wax and a solvent. This is perfectly all right, but it creates quite a different effect and is not true encaustic.) You could lay the foundation for an encaustic painting on wood by covering the support with high-quality, absorbent printmaking (Rives BFK) or watercolor paper. If you use an acrylic medium as your glue, be sure that none of it penetrates the paper, or you will end up with a nonabsorbent polymer film. You might also use true gesso (not acrylic) or rabbit skin glue.

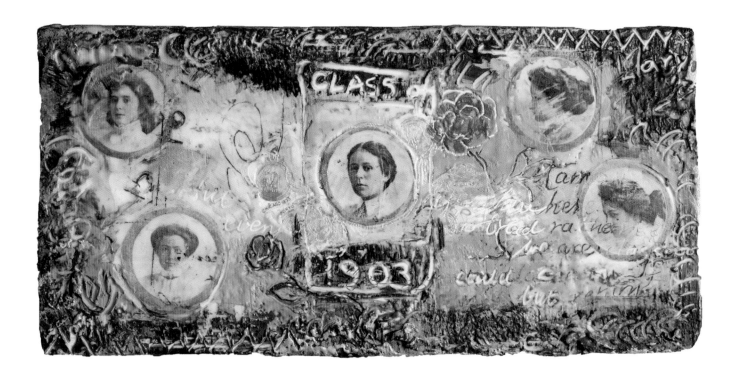

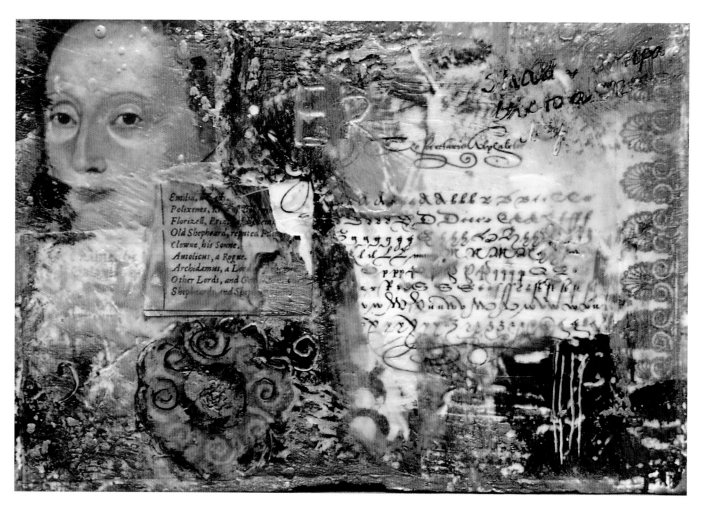

ABOVE: *Class of 1903*, Ann Baldwin, 5" x 9" (12.7 x 22.9 cm), encaustic, collage on cigar box lid.

BELOW: *Elizabeth R*, Ann Baldwin, 7" x 10" (17.8 x 25.4 cm), encaustic, collage on 300 lb. (136 kg) water-color paper.

Palimpsest #3, Ann Baldwin,
10" x 8" (20.3 x 25.4 cm),
encaustic, collage on
Masonite glued to canvas
on heavy stretcher bars.

HOW CAN YOU REDUCE THE OPACITY OF ENCAUSTIC PAINTS?

That's an easy one—transparency can be increased by adding more clear medium. Encaustic medium is a mixture of pure beeswax and dammar resin in various proportions. The resin hardens the wax. If you add too much, your layers will be brittle and easily chip off, especially at the edges. As you become more experienced, you can alter the ratio of dammar to beeswax to suit different purposes. For example, if you plan to scratch and gouge your surface, use more resin. If you want smooth, transparent layers or if you're going to scrape off part of a layer to reveal what's underneath, use less. On the whole you should use about six times as much medium as paint. This means that the paint goes a long, long way.

Rites of Passage,
Ann Baldwin, 8" x 10",
(20.3 x 25.4 cm), encaustic,
collage on Masonite glued to
canvas on stretcher bars.

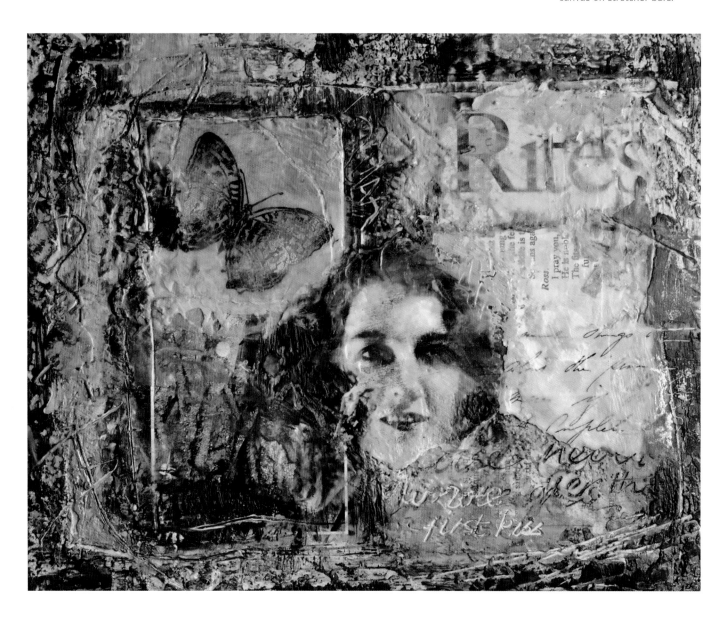

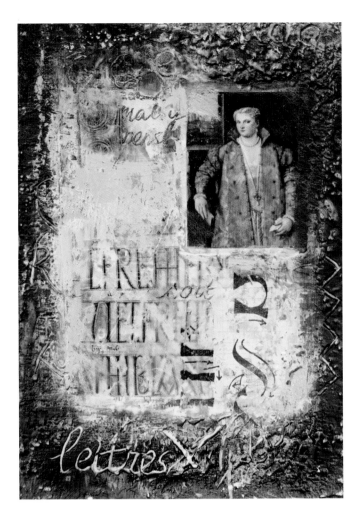

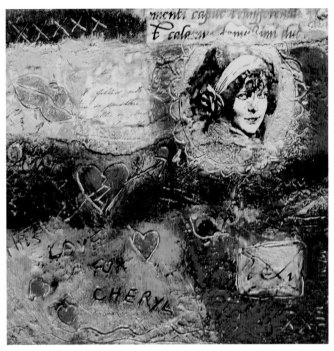

LEFT: *The Velvet Coat*,
Ann Baldwin, 10" x 6"
(25.4 x 15.2 cm), encaustic,
collage on cigar box.

RIGHT: *Love for Cheryl*,
Ann Baldwin, 12" x 12"
(30.5 x 30.5 cm), encaustic,
collage on birch panel.
Collection of Merrill Mack.

HOW DO YOU AVOID MELTING PREVIOUS LAYERS WHEN FUSING?

This is a tricky technique. It's best to use a heat gun with low, medium, and high settings, as well as a fan that runs at different speeds. You can control the degree of melting by varying the distance at which you hold the heat gun from the surface. As soon as you see the wax gleam, move the heat source to the next area. That gleam is all you need to fuse two layers. If your heat source is too close or set too high, you'll melt several previous layers and the colors will mix to mud. Lightly touching a small travel iron on a medium setting to the surface will often be enough for fusion.

HOW DO YOU ADD COLLAGE TO WAX PAINTINGS?

You can, of course, begin by gluing images to your support. Again, be careful not to let the acrylic medium penetrate the paper. However, there's a better way. Keep a 12" (30.5 cm) electric deep-fryer (with its own thermostat) one-third full of melted medium. Using long, industrial tweezers, dip the collage paper into the medium, and then quickly transfer it to the support. If you're not quick enough, the medium will dry and the collage won't stick. Afterward, run an iron over the piece to fuse it to the layer below. In this case, an iron works better than a heat gun, which can end up causing the collage to float off in a pool of melted wax! If you've stuck the collage in the wrong place, you can easily remelt it and slide it around until you get it right.

HOW DO YOU USE STENCILS WITH HOT WAX?

Don't make the mistake of using plastic stencils. They give off toxic fumes and become horribly distorted. Some stencils are made of coated card, which are much better. You can also buy the card and cut your own. Brass stencils are also available, though these tend to be rather small. Once the stencil is in place, use a long-haired bristle brush that has been kept warm, to paint into the holes, as shown in the example to the right. Fuse the wax paint gently with a heat gun and cover the entire pattern with a layer of clear encaustic medium, which must also then be fused. This second fusing can more safely be done with an iron on a medium setting. Just keep experimenting and eventually you'll find you have more control.

BELOW: *Laced*, Ann Baldwin, 6" x 8" (15.2 x 20.3 cm), encaustic, collage, oil stick on cigar box lid.

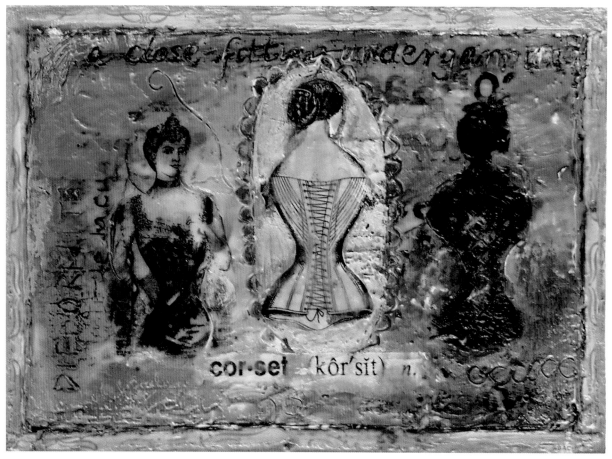

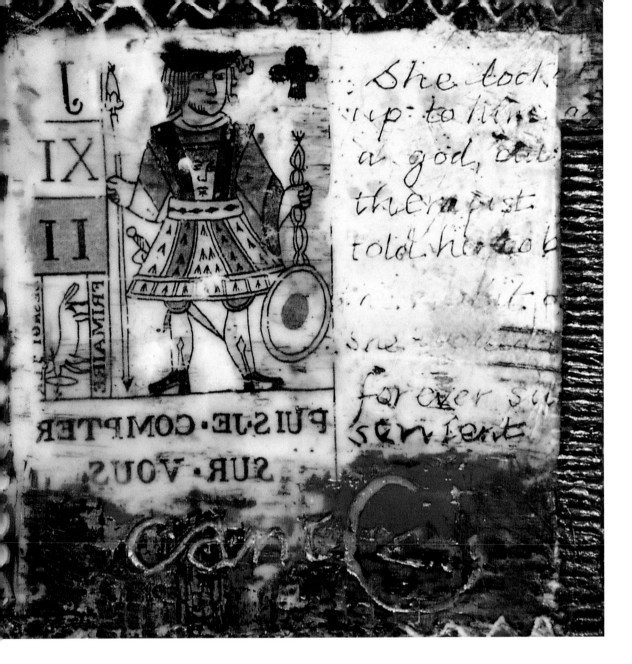

The Joker, Ann Baldwin, 8" x 8" (20.3 x 20.3 cm), encaustic, collage on Masonite.

HOW DO YOU CLEAN UP YOUR BRUSHES AFTERWARD?

My short answer is: don't! Keep a separate brush for each color. It's perfectly all right to allow the paint to dry on the brush while it's not in use. In fact, the wax preserves the brush. However, if you do want to clean a brush, all you need is some melted paraffin wax. Dip the brush into this and keep cleaning off the paint with strong paper towels. You can also use paraffin wax to clean your other utensils. Don't use it in your medium, though!

The best advice is: Experiment! Encaustic is a fascinating process, producing effects very different from oil or acrylic paint. Discover them for yourself!

Step-by-Step Encaustic Painting

Keep your first project simple. For this demonstration I painted on a small wooden box with deep sides, making it easy to handle. There are only three colors, which are applied in thin layers to keep the paint from getting too muddy from over-fusing. A simple grayscale digital photo printed twice on regular office paper provides a focal point for the more abstract textures and marks around it.

Materials

- wood panel
- R&F beeswax medium
- R&F powdered beeswax
- R&F paints: Alizarin Crimson,
- Chromium Oxide, Azure Blue
- images for collage
- cheap bristle brushes

- metal palette knife
- pointed metal object for etching
- travel iron
- griddle
- electric frying pan
- heat gun

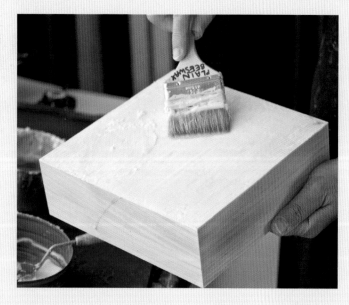

1 Cover the support with a layer of plain beeswax.

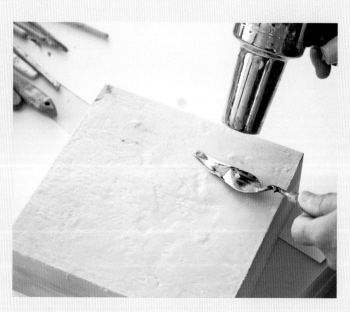

2 Fuse the bees wax into the wood with a heat gun.

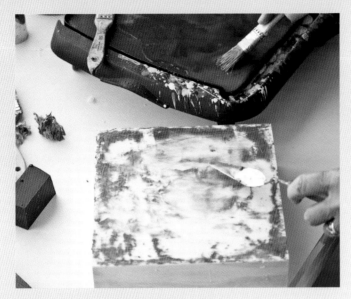

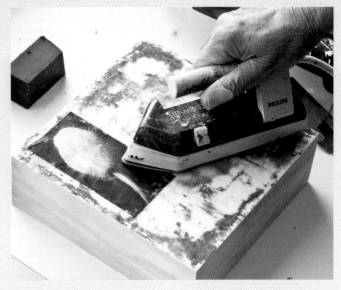

3 Transfer Chromium Oxide paint from the hot griddle with a brush and smoothed with a heated metal palette knife.

4 Dip the photo into melted wax medium, quickly place on the painting surface before it dries, then fuse with a hot iron.

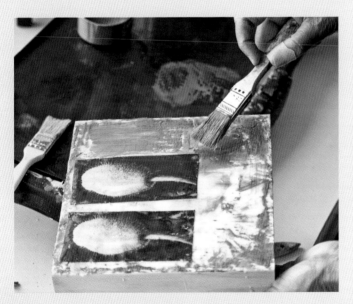

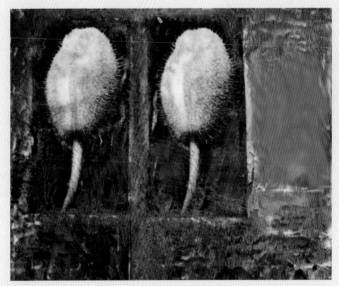

5 Lay a duplicate image down in the same way. Brush on a layer of Azure Blue paint and fuse with a heat gun.

6 Brush several layers of Alizarin Crimson thinned with melted wax medium onto the painting. Fuse each layer with the heat gun and allow to dry before proceeding to the next.

Step-by-Step Encaustic Painting (continued from page 111)

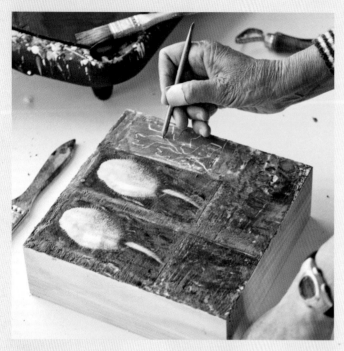

7 Use a hard metal tool to etch into the layer of paint, revealing the white background.

Papaver, Ann Baldwin,
9" x 9" (22.9 x 22.9 cm),
photos, encaustic on board.

*In the completed painting,
a stylized poppy flower and
the Latin name for poppy
have been etched into the
crimson paint.*

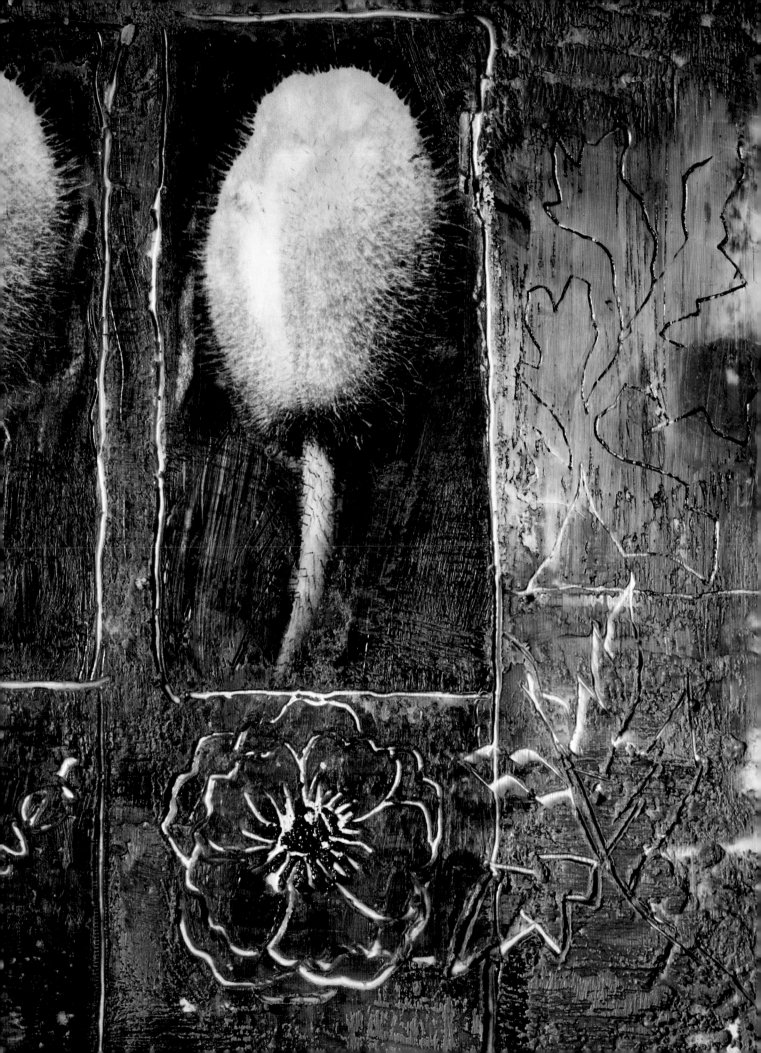

Using Digital Photographs in Mixed-Media Painting

With the proliferation of digital cameras and desktop printers, taking and printing photographs is available at low cost to everyone. Collage artists have long been using found photographs in their work. This, unfortunately, can lead to copyright infringement if the photos themselves are not in the public domain. Also it is not always easy to find just the right photo to fit the content of the piece. An easy way around this is to take your own.

Fennel, Ann Baldwin,
20" x 20" (50.8 x 50.8 cm),
digital photos, acrylic,
ink on canvas.

In this painting, several photographs have been pushed into the background by adding several thin layers of paint. The fennel image has been used three times: as a straight photograph, as a negative photograph, and finally as a rough drawing.

The search for particular imagery can be fun, making you observe the world with fresh eyes. Need a particular texture, such as a woven fabric, rusty metal, weathered wood, bark, sand? Go out and search for it and snap away.

Alternatively, take your camera out with you at all times and keep your eye open for new subjects. A section of that ornate gate could provide the perfect decorative touch. The silhouette of a bird, a leaf, an urn, a pinecone, an old car—all these have possibilities.

Photographing Individual Objects

Individual objects may be more challenging to photograph, depending on the lighting and the background. Say you want a photograph of a single rose to include in your mixed-media piece. Rather than shooting it in its natural setting on the bush, cut one of the blooms, and place it on a piece of paper in open shade to avoid harsh shadows. Position yourself directly above the flower with the lens parallel to the surface to keep everything in focus. With your camera in the auto or program mode, press the shutter. If you are able to, select "Shade" as your white balance setting. This will help you to avoid a color cast, which might make the white background look yellow or blue when you print out the image. With a white background, you won't have to laboriously cut out the rose. You can glue on the whole piece of paper and paint over its background later, making it easier to integrate it with other elements. I recommend creating a copy in black-and-white, giving more flexibility with paint

Look out for distinctive silhouettes against a still-bright sky at dusk. These are easily converted to black-and-white without having to alter the contrast.

Computer Manipulation

Some simple understanding of software such as Photoshop or Photoshop Elements will make it possible to achieve the results you want. For example, changing a color photo to black-and-white gives you more control over the way the image looks in your final painting. To add color you can use paint, colored pencils, or crayons before or after you attach it. Often a photograph needs adjusting for brightness or contrast, depending on how it is going to be used in your painting. The sliders in Photoshop are easy to use. Remember, you are not trying to become a professional photographer; you are merely adjusting images to suit your painting needs. There's a world of difference. If you'd prefer sepia over black-and-white, open the Adjustments menu and click on Hue/Saturation to open the box with the sliders. At the bottom right of the box, check the Colorize box and move the hue slider until you see the tone that you want. You may also need to move the saturation slider to the left to make the tone more subtle.

If you want to go a step further, special filters and effects can be applied in Photoshop Elements to make a photo look like a drawing, a poster, even a cartoon, all with the click of a mouse.

tip

When you must photograph something in its natural environment, make sure your cow, tree, or whatever it may be, is against a plain background. This may mean waiting until the cow has moved or changing your position. An isolated tree on top of a hill makes a good subject. A thistle can be isolated from the rest of the bunch, if you get down low enough to shoot it against the sky, or carry a large white card with you and place it behind the subject.

Printing Your Images

SIZE

Another advantage of having a stock of your own digital images on your computer is that you can print them out in any size and as many times as you want. That photo of a rose could be repeated several times on one sheet of paper. Photoshop will allow you to select different configurations of prints: two 5" x 7" (12.7 x 17.8 cm); four 4" x 5" (10.2 x 12.7 cm); eight 2½" x 3½" (6.4 x 8.9 cm), and so on. Repeated images make interesting compositional devices, encouraging the eye to jump from one area to another. You could create a border from dozens of prints of the same image glued around the edge of your support. You can even flip the image horizontally before printing and save another copy as a mirror image. How about a negative? Alternating negative and positive images can be very striking.

How large can you print a digital image before it gets pixilated (breaks down into ugly square blocks)? This depends on the resolution of the original photo. Unless you work on a very large painting surface, an 8" x 10" (20.3 x 25.4 cm) print at a resolution of 220 usually looks fine. If your camera has five or more megapixels, as most do, you won't have a problem. Also, bear in mind that you will often be covering your photo with thin layers of paint or marking them with other media, so the photo doesn't have to be perfectly clear in the first place. Even a slightly out-of-focus shot can work. The most important thing is good definition. If the image is all one value or has little tonal contrast, it won't attract much attention.

PAPER

There are a host of possibilities here, depending on the versatility of your printer. Believe it or not, ordinary inkjet paper works just fine for black-and-white photos. After all, collage artists often use photos from magazines or newspapers, none of which are acid-free. The fact is that, if you are going to adhere the photo with matte medium, and cover it with matte medium afterward, it will effectively be incased in polymer. This will prevent it from ever crumbling into dust. For color images, it is better to use a coated inkjet paper that will take the colors more crisply without bleeding. Matte photo paper is good, too, though it's thicker, requiring a less liquid medium for gluing. Soft Gel works well here. The one paper to avoid is glossy photo paper, as inks are more likely to smear and the shine has to be taken down with a matte medium to make it merge in with the rest of the painting. Some more expensive photo printers accept heavier specialty papers, like watercolor paper or canvas paper. There is really no need to use these unless you want to take advantage of the extra weight and texture in a particular area of your painting. They can be difficult to integrate. If you do use them, a more viscous glue such as YES! Paste (known as "the stick-flat glue") or heavy gel medium is recommended. It also helps to put glue on both surfaces—on the paper you are adhering and the surface it will be stuck onto. This will prevent areas lifting where there is not enough glue.

Golden digital grounds and inkAid are products for coating any paper or fabric to make it receptive to digital inks. The paper will usually need three or four coats, each being allowed to dry before applying the next. These mediums make it possible to print photographs on rice paper, book pages, wrapping paper, Mylar, cotton, or anything that you can put through your printer safely. Thinner papers may need to be taped to a "carrier" paper, such as regular typing paper, to ensure that it does not become jammed.

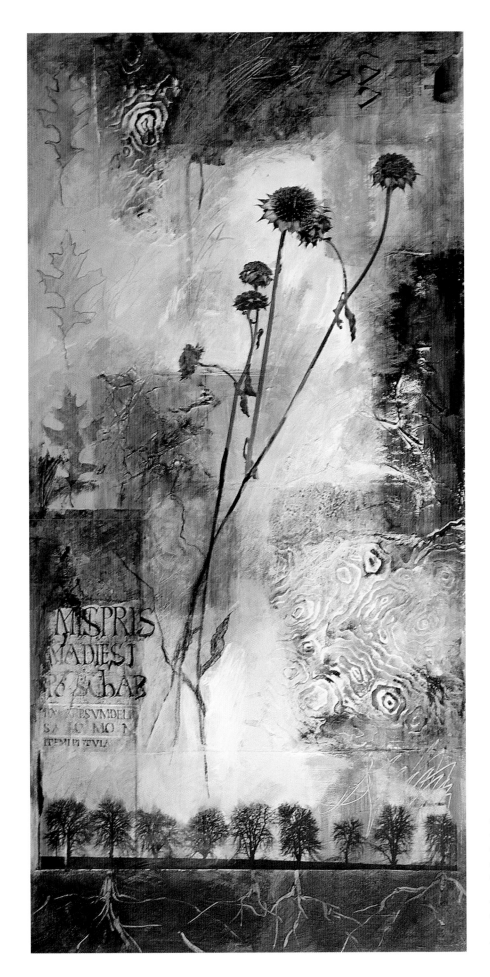

Contours, Ann Baldwin,
48" x 24" (121.9 x 61 cm),
digital photographs, crayon,
acrylic, modeling paste on
canvas. Private collection.

*For this painting the
photograph of the trees
was enlarged and printed
in two sections.*

INKS

How important it is to use archival inks when printing photographs for use in mixed-media paintings? One of the advantages of using your own photographs rather than finding images in magazines is that you have control over this aspect of your work. Therefore, the use of lightfast inks is advisable. The most well-known manufacturers all sell some printers with inks that will not fade for fifty years, provided they are not displayed in full sun. Some of the inks will last for 200 years, we are told, though we won't be around to test the claim. If your work is going to be put

away in a drawer and never displayed, it doesn't much matter what inks you use. But if you plan to frame, exhibit, sell your art, or pass it on as a gift, you will want it to look good for as long as possible. Some of Picasso's collages containing newspaper have yellowed with age, but they still look good. On the other hand, museum conservators are employed to ensure that they fade as little as possible. Unless you become very famous, you may not enjoy this luxury!

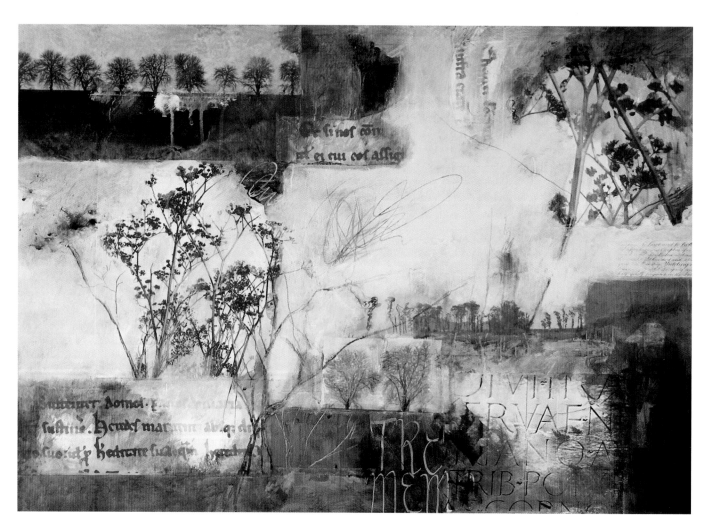

Watching Winter Fields, Ann Baldwin, 30" x 40" (76.2 x 101.6 cm), digital photos, acrylic, ink, collage on canvas. Private collection.

The juxtaposition of close-up images and distant trees creates an interesting spatial effect. Landscape photos can be printed in various sizes. Smaller images in a large painting give the illusion of distance.

Techniques for Incorporating Photographs into Paintings

Many of the techniques mentioned in chapter 6 apply here, so refer back to that chapter for guidance in glazing, disguising edges, making smooth transitions, tearing, and cutting. A series of photographs on the same theme can be made into one content-filled artwork or a series of related paintings.

Try taking different sections of the same photograph and assembling them in an almost abstract design. Or, using the grid as your structure, alternate panels of photographs with panels of paint.

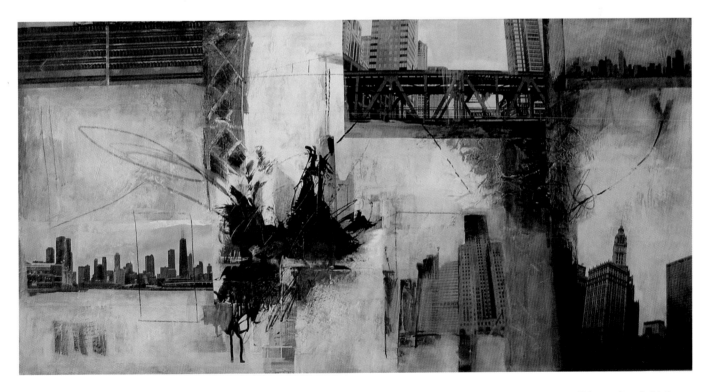

Chicago, Ann Baldwin, 18" x 36" (45.7 x 91.4 cm), digital photographs, ink, acrylic on canvas

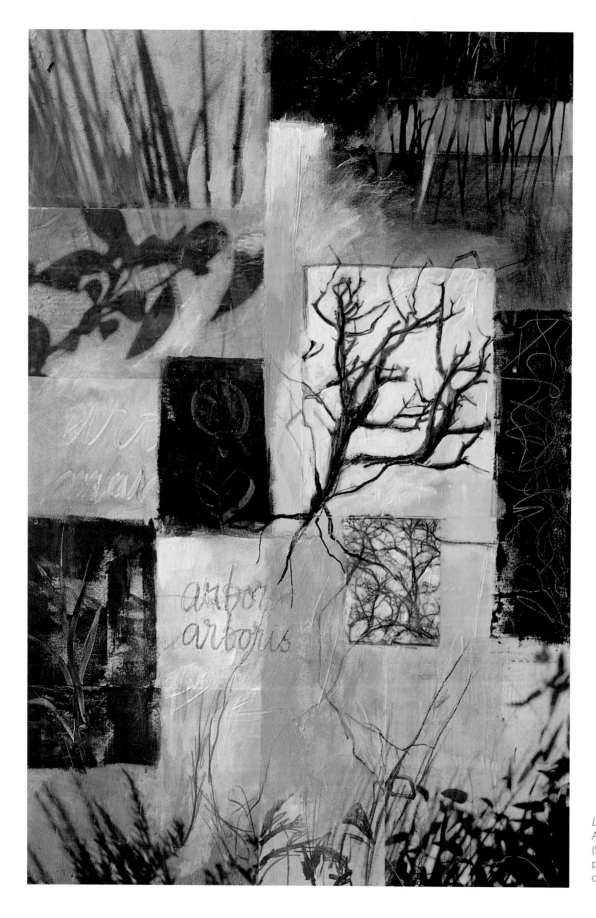

Leaf Shadows I,
Ann Baldwin, 36" x 24"
(91.4 x 61 cm), digital
photos, ink, acrylic on
canvas.

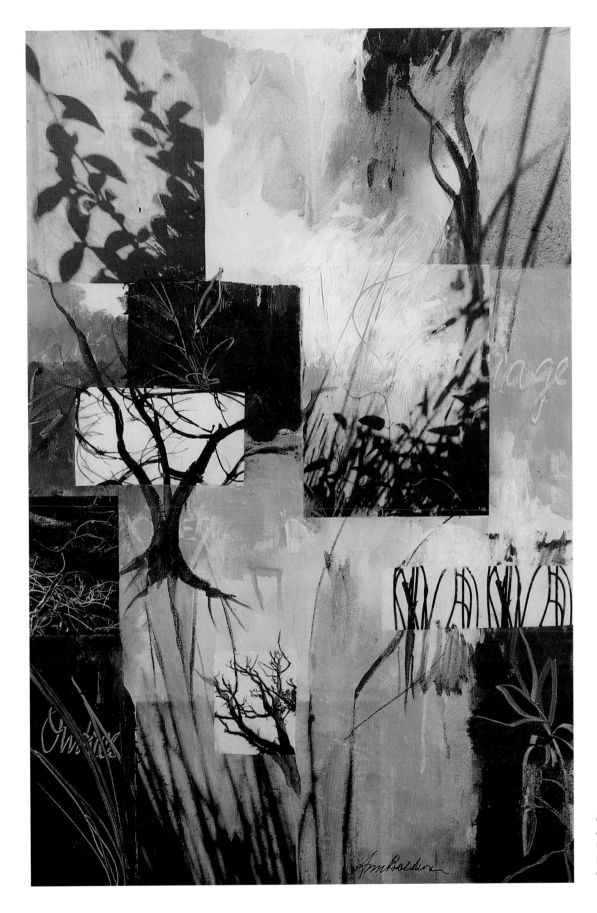

Leaf Shadows II,
Ann Baldwin, 36" x 24"
(91.4 x 61 cm), digital
photos, ink, acrylic on
canvas.

Step-by-Step Photo-Based Painting

This painting includes two original photographs. The tree photo has been printed twice, once as a positive image, and then as a negative. To create the negative, in Photoshop, go to Image/Adjustments/Invert. You may also need to increase the contrast to ensure that there's a clear distinction between black and white.

Materials

- pre-gessoed deep-sided canvas to use as a support
- flat nylon brush
- flat sponge-on-a-stick
- Golden Acrylic Fluids: Violet Oxide, Jenkins Green,
- Titan Buff, Transparent Red Iron Oxide matte medium

- collage elements: inkjet prints of original photos on Kodak Premium Bright White Paper (Canon waterproof inks), patterned tissue paper, purchased preprinted text
- rubber stamp of leaf

1 Cut or tear photos and other papers. Arrange them in an interesting design on the canvas. Glue them down by applying matte medium first to the canvas, then to the reverse of the papers. If you want the collage to lie flat, smooth out with a brayer. Some of the patterned tissue paper has been allowed to wrinkle to provide texture.

2 Using a sponge or a nylon brush, apply Violet Oxide as a glaze unevenly to different areas, rubbing it in with a paper towel. Dry with a hair dryer.

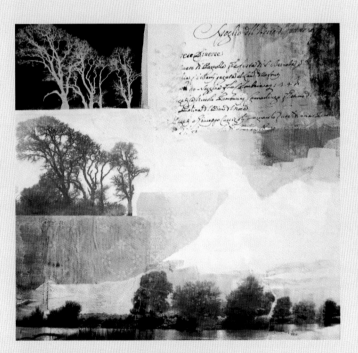

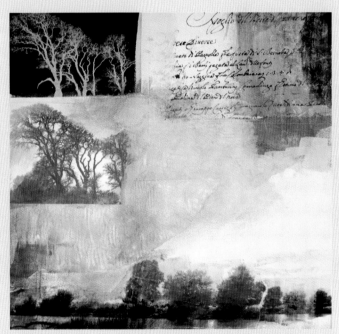

3 Cover all the collage with a layer of matte medium to seal it. Use Titan Buff to cover the remaining area of white canvas and to tone down the photo of the river at the bottom. Dry thoroughly, as you don't want the Titan Buff to mix with subsequent transparent glazes.

4 Run a thin glaze of Jenkins Green and another of Transparent Red Iron Oxide loosely over other areas of the painting. When this is dry, you may also decide to soften the effect with another layer of Titan Buff.

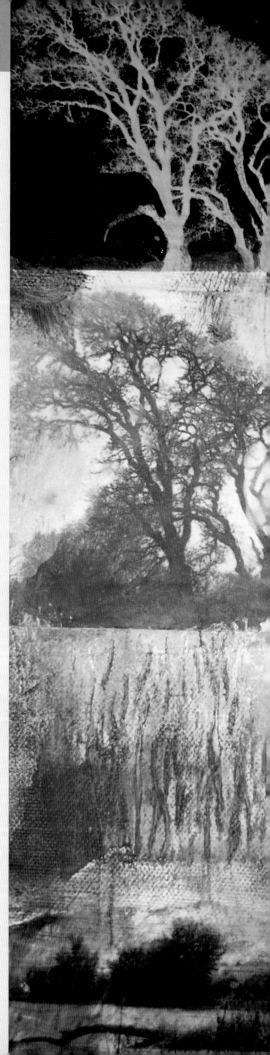

PROJECT

Step-by-Step
Photo-Based Painting

(continued from page 125)

Because black inks can be rather stark, it can help to use a color over the blackest areas. Here Violet Oxide has been used to give the black more warmth. The same color has been lightly rubbed over the creased tissue paper to bring out the texture. A rubber stamp has been pressed into a thin layer of heavy-bodied Violet Oxide acrylic, rather than using a stamp pad. To apply the stamp to the canvas, hold a piece of wood behind the area to keep the canvas firm as you press down.

Reminder: Be sure to scrub the paint out of your stamp thoroughly with a nailbrush immediately after you use it, or the acrylic will dry in the grooves and you will permanently lose the detail.

River in Flood, Ann Baldwin,
12" x 12" (30.5 x 30.5 cm),
mixed media on canvas.

TIPS FOR USING PHOTOGRAPHS IN COLLAGE

- Don't use the original print if it's important. You might ruin it. Use reprints, photocopies, or digital scans.

- Check that the ink is waterproof before sticking it down. Rub a moistened brush over a small area to see if the ink lifts. If it bleeds badly, don't use the photo.

- Try ironing non-waterproof photos. Place a piece of tracing paper over the image, turn off the steam, and run a hot iron over the paper several times. This will often set the ink into the fibers of the paper. I have sessions ironing large numbers of photocopies and photographs!

- For those photos that are slightly less than water-proof, I stroke on a light barrier of Soft Gel medium and let it dry thoroughly before using any paint.

- Consider the type of paper. A glossy photo may lose its emulsion when it is made wet. Thin paper photo-copies or inkjet prints will soak up the ink so quickly that it is hard to apply light colors. Before you paint, brush on a layer of matte medium and let it dry. This prevents the paint from soaking into the paper.

- Thick paper will be harder to adhere. Use a heavier adhesive such as heavy gel medium or YES! Paste. Thin paper will stretch and wrinkle more easily when wet, so use a brayer to smooth out the air bubbles. (Push in one direction only!) Use the adhesive on both surfaces. But remember, a few wrinkles can add character and texture to your mixed-media painting.

- It's usually easier to work with black-and-white photographs, rather than color. Inkjet colors will be altered unpredictably by applications of transparent fluid paints—you may like this or you may not. When printing in black-and-white, try not to make the blacks too deep, as they "deaden" the painting. Photocopy blacks are particularly difficult to alter with paint. Set the copier to a lighter setting. Where blacks are too dark, consider coloring over them with colored pen-cils prior to sticking down the image. In fact, I often enjoy coloring clothes and hair and applying makeup with crayons or colored pencils to give the piece a handmade look.

SOMETHING DIFFERENT: WAX WITH PHOTOGRAPHS

Both these photographs were initially created from several individual photos composited and blended in Photoshop. These were printed on watercolor paper pre-coated with inkAid and Golden Digital Semi-Gloss Ground. The photos were glued onto board with matte medium. Beeswax and resin medium were melted and painted onto the photo-graphs and fused with a hot iron. (See chapter 7, page 98, for details of the encaustic process.) The edges were embellished with textured wax paint.

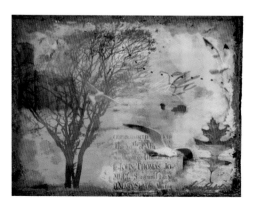

ABOVE RIGHT: *Guardian*, Ann Baldwin, 12" x 17" (30.5 x 43.2 cm), digital photo composite on board, beeswax medium, encaustic paints.

BELOW RIGHT: *The Abandoned Castle*, Ann Baldwin, 11" x 14" (27.9 x 35.6 cm), digital photo composite on clayboard panel, beeswax medium, encaustic paints.

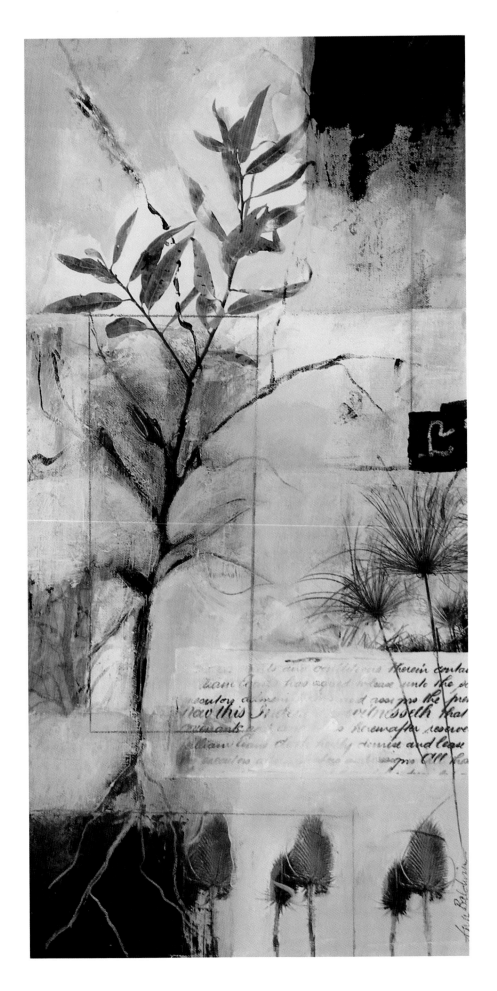

Three Seasons, Ann Baldwin, 20" x 10" (50.8 x 25.4 cm), digital photos, acrylic, collage on canvas. Private collection.

Gallery of Special Projects

Questions, Thomas Morphis,
10" x 8" (25.4 x 20.3 cm),
mixed media

The piece began as a collage, to which acrylic paint, pencil, and found objects were added. Next, an epoxy-like resin was poured over the surface, sealing everything within. When the resin hardened, additional paint and drawing with china marker was added. This layer hovers slightly over the surface, casting a subtle shadow. Another protective top coat of resin finished the piece.

Code Blue, Joan Hauck,
30" x 26" (76.2 x 66 cm),
mixed media

Melted wax was applied with a brush to a wood panel in thin layers. Each layer was fused to the previous one, using a heat gun or blow torch, which also smoothed the wax. It was then incised with dental tools and found items—ravioli cutter, bottle cap—impressed into the warm wax. The entire piece was then heavily slathered with a burnt umber oil stick, which was then rubbed off, leaving some in the crevices.

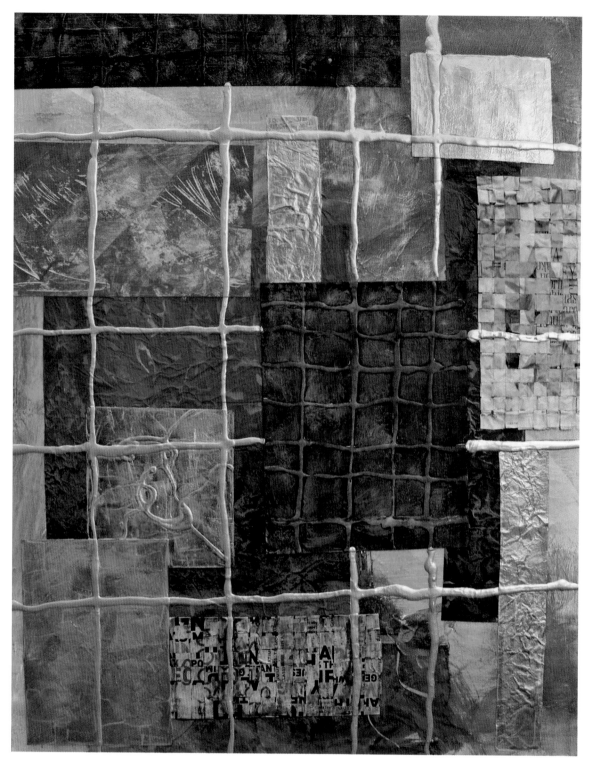

Undercover, Joan Hauck,
28" x 22" (71.1 x 55.9 cm),
acrylic, collage on canvas.

The base coat is a thin acrylic glaze, on which puddles of darker tones were dropped and chased around with a hair dryer until dry. Some collaged elements are woven strips of magazine pages; some are acrylic medium applied with a squeeze bottle and allowed to dry, forming ridges, then layered with glazes of paint, then unthinned darker paint rubbed on and rubbed off, leaving some in the crevices; some are crumpled paper painted and then glazed with a darker paint, which was rubbed off. The whole thing was tied together with unthinned gold paint applied with a squeeze bottle.

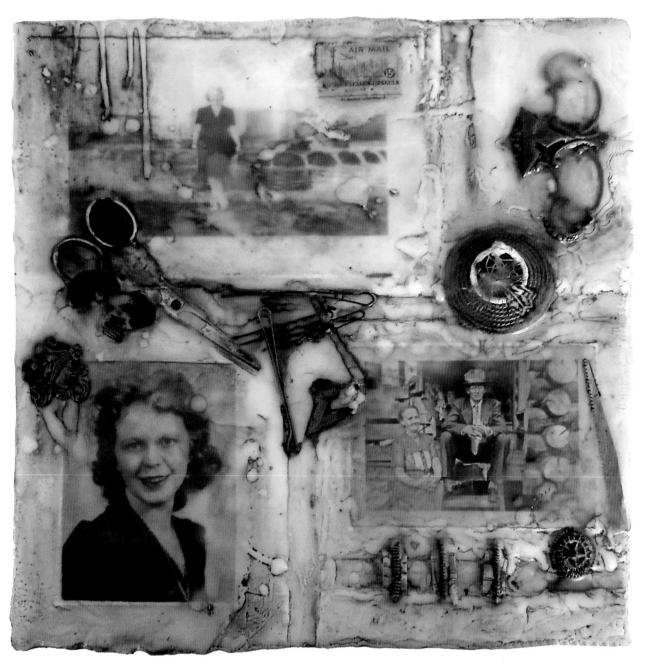

Swing Shift Maizie,
Sandi Miot, 12" x 12" x 3"
(30.5 x 30.5 x 7.6 cm),
encaustic, photos,
found objects on board.

Layers of melted clear, non-pigmented encaustic (beeswax and dammar resin) were brushed onto a cradled wood support to which paper had been glued to the surface. Old family photos were then scanned and printed on matte photo paper, dipped into the encaustic, and collaged onto the support, along with other mementos. A burnt umber oil pigment stick glaze was applied and rubbed off, leaving the oil stick to fill the crevices, and then fused with a heat gun.

LEFT: *Pastel Apple 1*,
Thea Schrack, 24" x 16"
(61 x 40.6 cm), photography
with encaustic wax painting.

BELOW: *Prairie Grass*,
Thea Schrack, each panel
16" x 16" (40.6 x 40.6 cm),
photography with encaustic
wax and oil paint.

*Color photography, printed
with archival pigment inks, is
combined with a number of
layers of encaustic wax and
oil paint. The photograph is
first mounted on board. It is
then painted with a combina-
tion of beeswax, resin, and
pigment, heated to around
220°F (104°C). Each sepa-
rate layer of wax is fused
with a heat gun.*

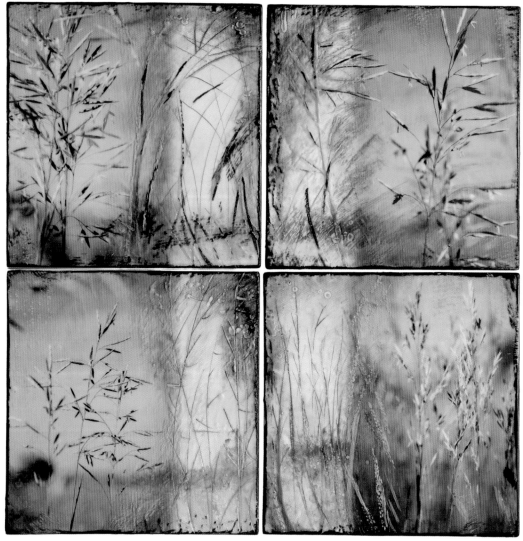

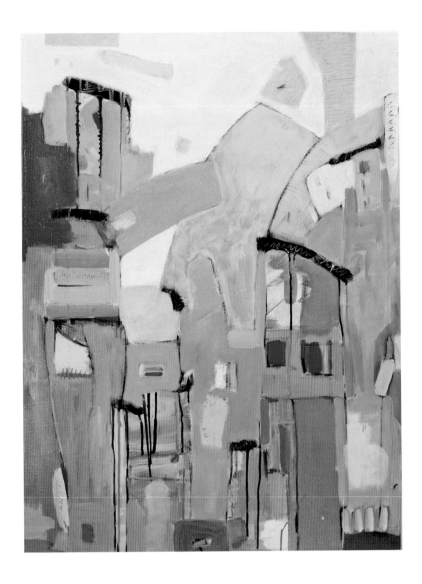

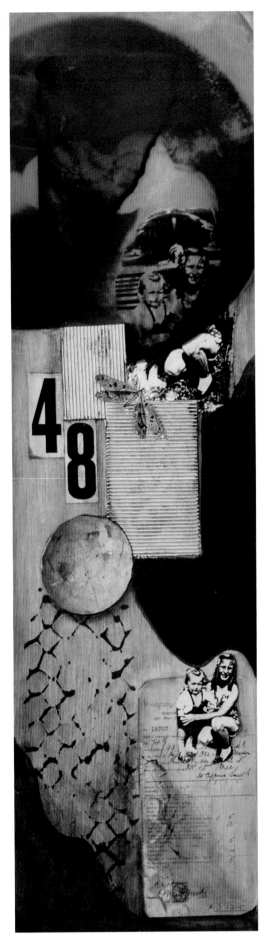

ABOVE: *A Leg Up*, Louis Bording, 40" x 30" (101.6 x 76.2 cm), mixed media on canvas.

The painting process consists of applying very loose acrylic paint with no predetermined image in mind, then drawing into the wet paint with charcoal to define major shapes. Preliminary color and line work may be obliterated in the final image. The title is determined by the imagery in the final painting.

RIGHT: *1948*, Beryl Miller, 24" x 7" (61 x 17.8 cm), mixed media on panel.

Starting with a memory, an old document, a photo (and an enlarged copy of the same photo), X-ray, magazine picture, corrugated paper, acrylic paint, the pieces were moved around on the birch panel until they made a pleasing design. The pieces were then glued down with matte medium, paint was used to make shapes and lines, the entire piece was painted with acrylic semigloss and sanded with 360-grit sandpaper when dry. Wax was applied and the piece was buffed to give it a soft patina.

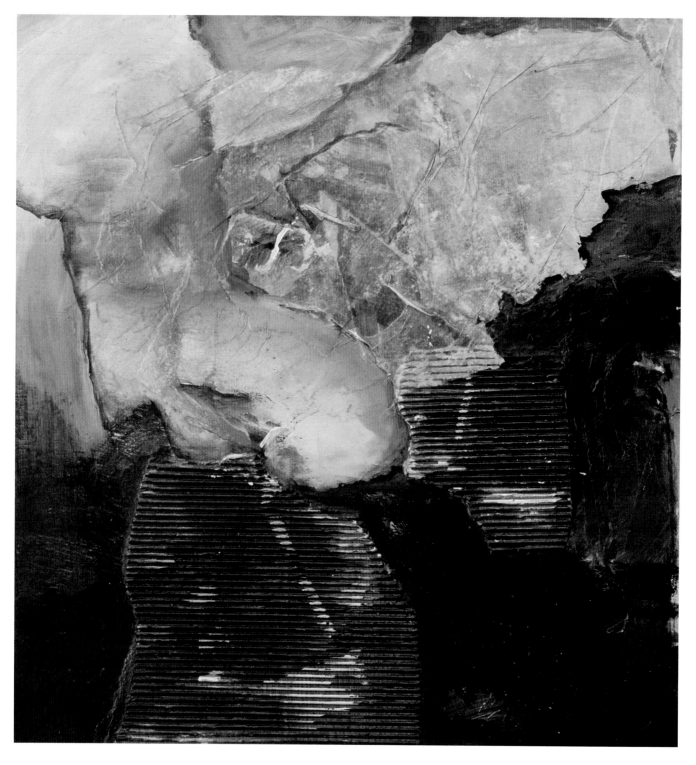

Night and Day, Beryl Miller, 12" x 12" (30.5 x 30.5 cm), mixed media on canvas.

Corrugated paper and torn-up old paintings were arranged so that the edges made interesting lines. Some lines were added with acrylic paint and white and black conte crayons. The whole painting was then coated with a very light umber glaze in semi-gloss medium before it was sanded with 360-grit sandpaper, waxed with cold wax, and buffed.

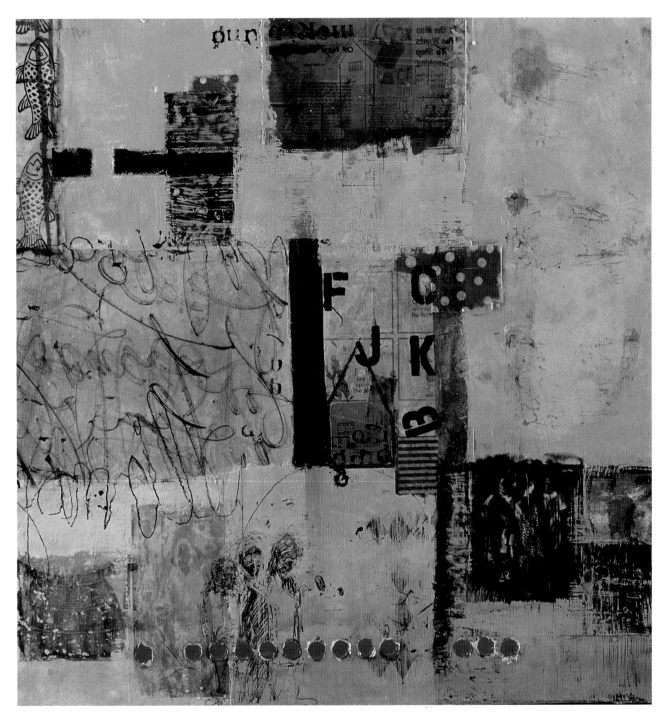

La Familia, Mary Black, 36" x 36" (91.4 x 91.4 cm), encaustic, mixed media on wooden panel.

The painting, La Familia, *was created using encaustic paint. What makes encaustic, "encaustic" is that each layer of paint must be fused, using a heat gun, onto the previous application of paint. It's an amazing process in that the material becomes solid and hard very quickly. In this particular painting, which is on a birch panel, a variety of collage materials are used, some from very old newspapers. The wax surface has been drawn onto with charcoal, which works very well with the encaustic paint. Using this medium allows the creation of transparencies and oftentimes glasslike surfaces. Because this piece became quite thick in some areas, the paint was scraped away, revealing what's underneath and the history of the painting process.*

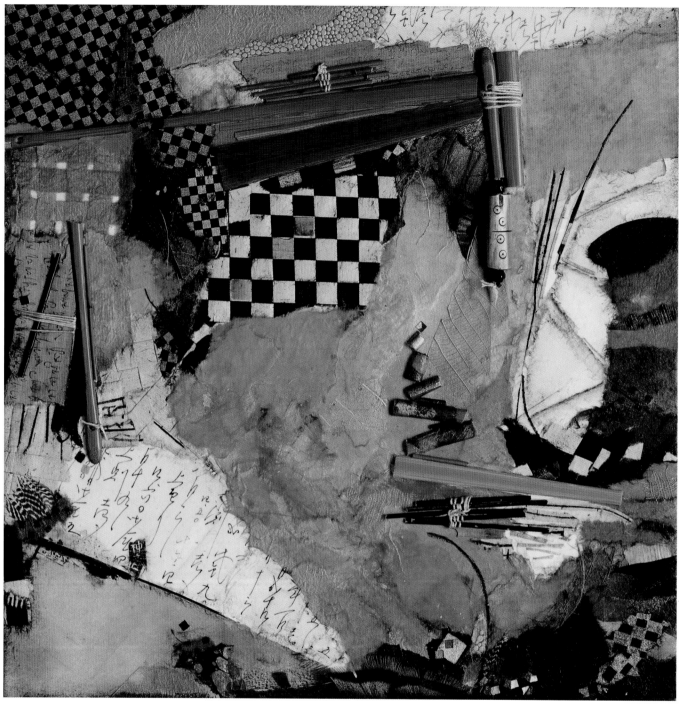

Another Invitation to Play,
Louise Forbush, 12" x 12" x 2"
(30.5 x 30.5 x 5.1 cm),
mixed media collage on
wood panel.

*A cradled wood support was first covered with torn pages
from antique Japanese books to create an old-world
base of tones and textures. That was then built up (and
mostly covered) with handmade papers, wood pieces from
old fans, reeds, feathers, linen thread, and other objects.
Papers were affixed with spray glue, heavier objects with
PVA. Acrylic washes were added for warmth and,
occasionally, for color. The piece was finished with
several coats of matte varnish.*

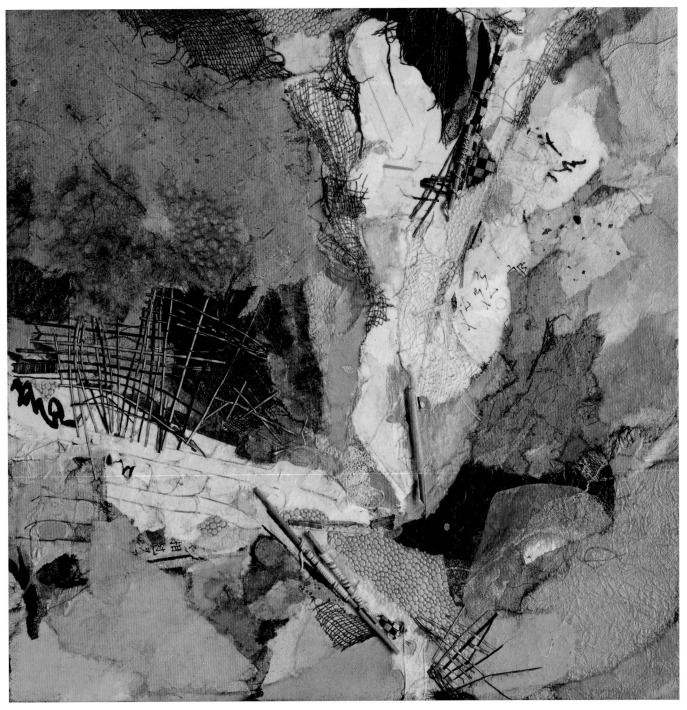

Grand Canal, Louise Forbush, 12" x 12" x 2" (30.5 x 30.5 x 5.1 cm), mixed media collage on wood panel.

A cradled wood support was first covered with torn pages from antique Japanese books to create an old-world base of tones and textures. That was then built up (and mostly covered) with handmade papers, reeds, dyed and natural cheesecloth, and linen thread. Papers were affixed with spray glue, heavier objects with PVA. Acrylic washes were added for warmth. The piece was finished with several coats of matte varnish.

The Apothecary's Apprentice,
Karen Hatzigeorgiou, 10" x
10" (25.4 x 25.4 cm), mixed
media on paper.

*This altered book started as a children's board book.
After cutting the niches for the bottles and main image,
torn pieces of paper in shades of blue, white, and silver
were applied. A wash of blue acrylic inks was added to
unify the papers and make them blend together. An image
transfer of the globes and trajectory lines was added, as
were the rubber stamped circle and square patterns. Tiny
stars, beads, bottles, game pieces, toile net, and stickers
were all used to embellish the piece and highlight the
central image of the girl on the moon.*

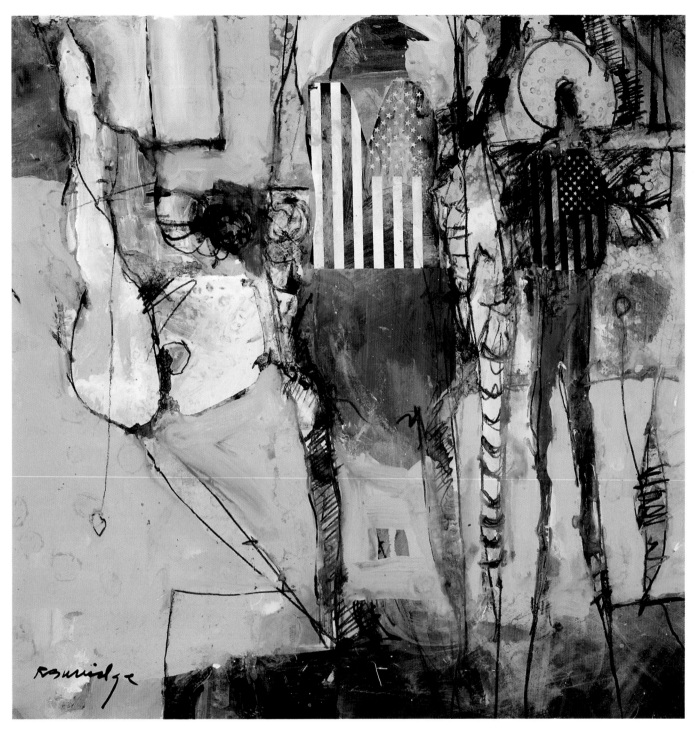

Line Judges, Robert Burridge, 22" x 22" (55.9 x 55.9 cm), mixed media on paper mounted on canvas.

This purely whimsical line drawing was created with water-soluble black pencils in one hand and a large brush loaded with acrylic paint in the other hand. While the paint was still wet, preprinted striped paper was stuck directly into the paint. After it had dried, a final coat of semigloss archival polymer acrylic varnish was brushed on to bring out the depth and colors that might have gone unnoticed.

Contributing Artists

Mary Black

Mary Black received her M.F.A. from the San Francisco Art Institute and B.F.A. from Sonoma State University. Her abstracted encaustic paintings have been exhibited nationally to include the prestigious Encaustic Works '07 juried by acclaimed artist Joan Snyder. A recipient of many awards, recently her work was chosen to appear on the label of the Eric Kent Wine Cellars 2005 Chardonnay wine. Her art has been published frequently. Mary and her husband reside in Sonoma County, California, where they grow premium Chardonnay grapes in the Russian River Valley.

www.maryblack.net
beeswax@sonic.net

Louis Bording

Louis Bording, a native of San Francisco, received his art degree from Skidmore College, New York. He then spent a year traveling in Europe. He is currently a member of SOMA Artists Studios in San Francisco, where he maintains his own studio. His work is exhibited regularly in the San Francisco Bay Area.

www.louisbording.com
louisbording@hotmail.com

Robert Burridge

Robert Burridge is a painter in all media, national juror, and college and national workshop instructor, and he is the honorary president of the International Society of Acrylic Painters. A signature member of both the Philadelphia Water Color Society and the ISAP, his honors include the prestigious Crest Medal for Achievement in the Arts and Franklin Mint awards. His work is featured in many books and magazines, on Starbucks Coffee mugs, on Pearl Vodka bottles and on eight commercial tapestries. His paintings are sold in galleries worldwide, including Sausalito, Raleigh, Sedona, California, Bend, Oregon, Hawaii, and on cruise ships. His country barn studio is located on California's central coast in San Luis Obispo County.

www.robertburridge.com
rburridge@robertburridge.com

Louise Forbush

Born and raised in New England, Louise Forbush spent several years working in music and the arts in London, and later lived in Japan, taking workshops in ikebana and papermaking. She's lived and worked in California for more than twenty years and has her studio in Sausalito. She is represented by ACCI Gallery in Berkeley, California, and has participated in many Bay Area solo and group shows.

www.louiseforbush.com
lforbush@aol.com

Karen Hatzigeorgiou

Karen Hatzigeorgiou is a part-time artist and a full-time seventh grade English teacher. She has taken art classes with collage artists Jonathan Talbot and Ann Baldwin. She is a member of Arts Benicia in Benicia, California, and has shown her work in several locations throughout the state. "The Apothecary's Apprentice" was published as a note card and calendar through Amber Lotus Publishing in 2004.

www.karenswhimsy.com

Joan Hauck

Joan Hauck received her B.A. degree in art from Douglass College in New Jersey, but she has been a Californian for many years. Her traditional oil landscapes have gradually morphed into abstraction, in acrylics, mixed media, encaustic, and fiber work. Her work has been shown in solo and group shows in California and appears in collections in the United States and in Ibiza, Spain.

www.joanhauck.com
joanhauck@mac.com

Beryl Miller

Beryl Miller was born in England, raised in Canada, and moved to San Francisco as a young woman. She raised a family, doing house remodeling, carpentry, painting, and production art pieces. She studied with various private instructors and at U.C. Extension and College of Marin. She has worked with painting, photography, jewelry, and lithography. In the past eight years she has won prizes in juried shows and exhibited in many galleries throughout Northern California. She has a studio at the Novato Art Center where for the past nine years she has concentrated on her real love, painting.

www.berylmiller.com
beryl@berylmiller.com

Sandi Miot

Sandi Miot is a California artist working primarily in encaustics. Her work is known and collected both nationally and internationally and has appeared on the sets of popular TV shows such as "Friends," "ER," and "CSI: Miami." She has studied and worked extensively in a variety of mediums, from clay and glass to oil, pastels, and watercolor, but she especially loves the ancient mediums such as encaustic and gold leaf.

www.sandimiot.com
sandi@sandimiot.com

Thomas Morphis

Thomas Morphis has exhibited his work in almost twenty solo shows and has participated in around 100 group shows across the United States. He has a B.F.A. from Pacific Northwest College of Art and an M.F.A. from Cranbrook Academy of Art. His studio is in Napa Valley, where he has taught painting for more than twenty years.

www.thomasmorphis.com
thomas@thomasmorphis.com

Resources

Aaron Brothers, Inc.

1221 South Beltline Rd.
Suite 500
Coppell, TX 75019 USA
Phone: 972-409-1300
art supplies, framing
www.aaronbrothers.com

Above the Mark

P.O. Box 8307
Woodland, CA 95776 USA
Phone: 530- 666-6648
unmounted vintage rubber stamps
www.abovethemark.com

Ampersand Art Supply

1500 East Fourth St.
Austin, TX 78702 USA
Phone: 800-822-1939
painting panels, boards, boxes,
and clay tools
www.ampersandart.com

Dick Blick Art Materials

P.O. Box 1267
Galesburg, IL 61402-1267 USA
Phone: 800-828-4548
art supplies
www.dickblick.com

Documounts

3265 N.W. Yeon Ave.
Portland, OR 97210 USA
Phone: 800-769-5639
mat boards, clear bags, framing
www.documounts.com

Golden Artist Colors, Inc.

188 Bell Rd.
New Berlin, NY 13411-9527 USA
Phone: 800-959-6543
acrylic paints, mediums
www.goldenpaints.com

The Home Depot

stores located throughout
the United States.
paintbrushes, sponge sticks, cheese-
cloth, wallpaper frieze
www.homedepot.com

Michaels Arts & Crafts

stores located throughout
the United States.
art and craft supplies, framing
www.michaels.com

Office Depot

stores throughout the United States.
stationery supplies
www.officedepot.com

R&F Handmade Paints, Inc.

84 Ten Broeck Ave.
Kingston, NY 12401 USA
Phone: 800-206-8088
wax paints, mediums, heating
equipment
www.rfpaints.com

Target

stores located throughout
the United States.
kitchen equipment suitable
for encaustic painting
www.target.com

About the Author

Ann Baldwin is an internationally known mixed-media artist and workshop teacher. Her work has been exhibited in more than 150 solo and group shows throughout the United States. She is represented by several galleries and her work appears regularly on the sets of primetime television shows and in movies. Articles about her have been published in magazines in the United States, Canada, and Australia. She was born and educated in Britain, where she taught English and drama to high school students for many years. In 1990 she immigrated with her husband to the San Francisco Bay Area, where she maintains a studio in her home on the edge of Napa Valley. She likes to spend long summers with her family in the UK and France. She has two daughters and five grandchildren. Besides painting, her interests are photography, gardening, walking, reading, and watching wildlife.

Acknowledgments

Ever since I was eight years old I have wanted to write a book, although what I really had in mind was a novel. In fact, in my early twenties I wrote a couple of those, which remained safely locked away in my filing cabinet for many years! I want to thank Mary Ann Hall, my editor, for contacting me out of the blue to write this book and encouraging me to believe I could do it when the project at times seemed overwhelming. Just to make life harder, I also undertook to shoot all the photographs. My thanks are owed, therefore, to David Martinell for his support and evaluation along the way.

As a self-taught artist who turned to painting relatively late in life, I know how important certain fellow artists have been in encouraging me to pursue my passion: Merrill Mack, who took me to the jungles of Mexico to teach a workshop; Beryl Miller, Collin Murphy, and Cathy Coe, whose creativity has fed my own; Sandi Miot, who held regular critiques in her studio and sowed the seeds of many projects; Mary Black, who introduced me to the sensuality of encaustic painting; Thea Schrack, whose photography inspired me to become a photographer myself; and Katrina Wagner, whose no-holds-barred evaluations took me kicking and screaming to the next level.

In recent years my association with Art & Soul Retreats (www.artandsoulretreat.com) has given me the opportunity to teach workshops, where I have met hundreds of aspiring and accomplished artists from the United States and beyond. Thank you, Glenny Densem-Moir and Cindy O'Leary, for organizing these incredible events. Thanks, too, to Vince Fazio of the Sedona Art Center for the opportunity to spend time in such a spiritual place and to teach art to talented students and teachers from across the world.

There is one small group of women who have helped me indirectly to complete this book: the ladies of the Hiddenbrooke Book Club, who have provided light-hearted relief from the rigorous hours spent alone in front of my computer.

Not least, I owe a debt of gratitude to my family: to my daughters, Helen and Alexa, who have endured my obsessive enthusiasm for things artistic and who hang my work in their homes for all to see; and to my mother and brother, whose pride in my achievements has been loudly and frequently spoken.

Finally to my husband, Mike, I owe boundless gratitude. I could not wish for a more dedicated and utterly selfless supporter. Despite the demands of his own career in scientific research, he has always been there to encourage my efforts, to frame, schlep, ship, and hang my paintings, to remodel my studio, build my booth at art festivals, and to accompany me to exhibition openings. How did I get to be so lucky?